Nineteenth-century Dutch artist Vincent van Gogh painted for only eight years. During that time, he was scorned or, at best, ignored; only one of his paintings was sold during his lifetime. And yet, although plagued by self-doubt, Vincent instinctively viewed the world through the eyes of an artist. The resulting paintings and drawings stand as a powerful and lyrical testament to the ultimate triumph of this brilliant man.

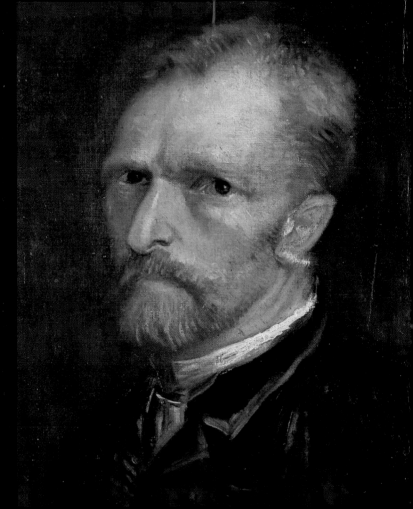

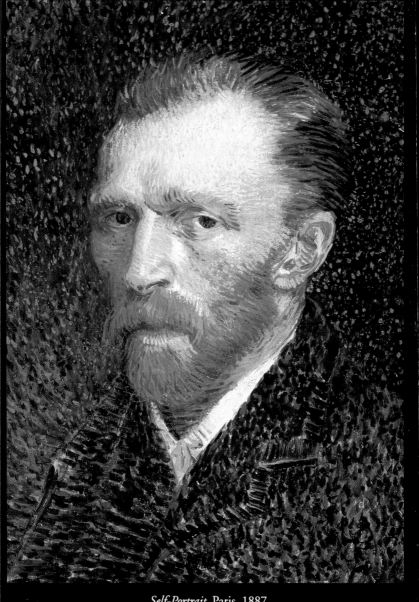

Self-Portrait, Paris, 1887.

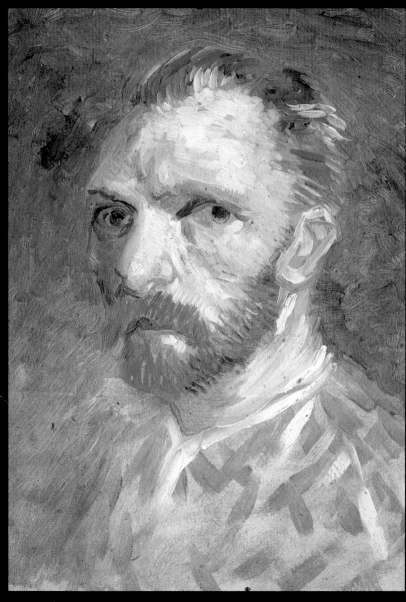

Self-Portrait, Paris, 1887.

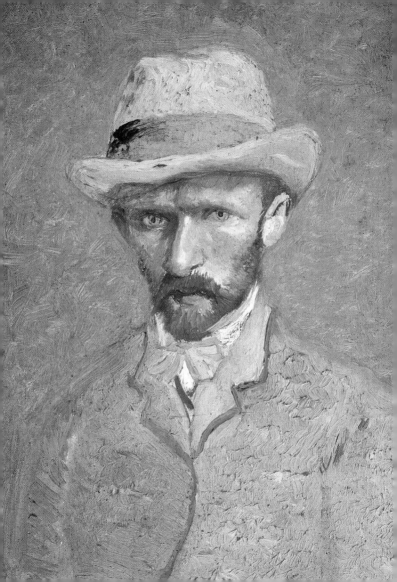

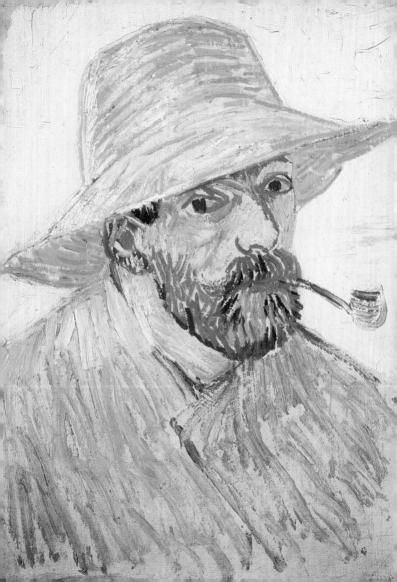

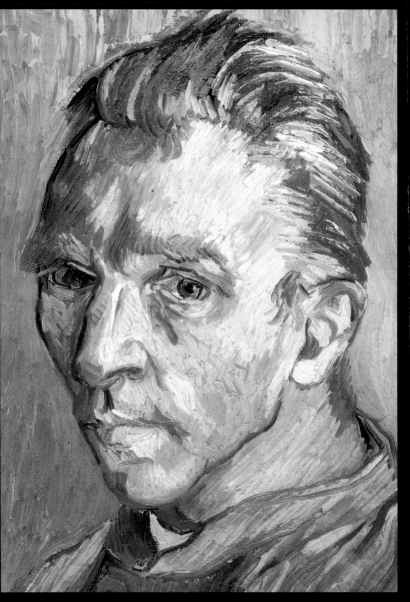

Self-Portrait, Arles, 1888.

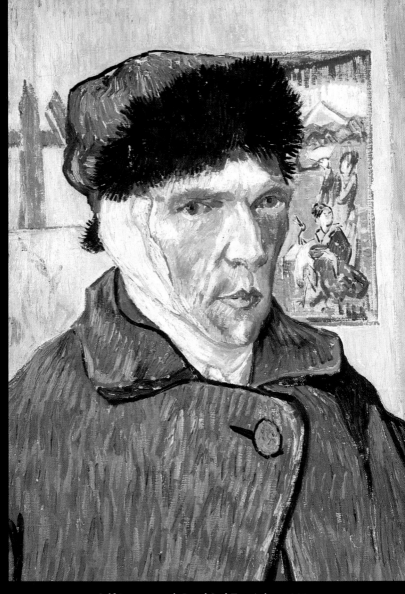

Self-Portrait with Bandaged Ear, Arles, 1889.

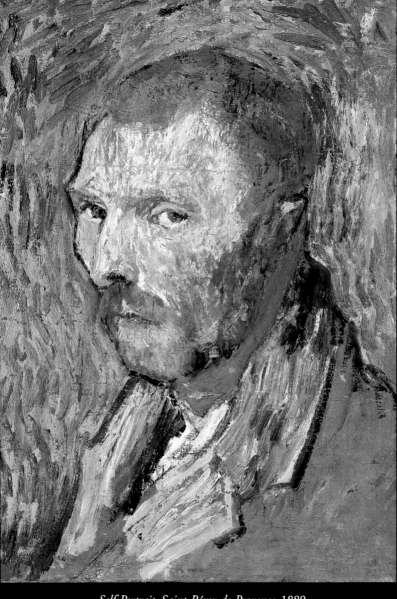

Self-Portrait, Saint-Rémy-de-Provence, 1889.

CONTENTS

VAN GOGH
THE PASSIONATE EYE

Pascal Bonafoux

DISCOVERIES

HARRY N. ABRAMS, INC., PUBLISHERS

NEW YORK

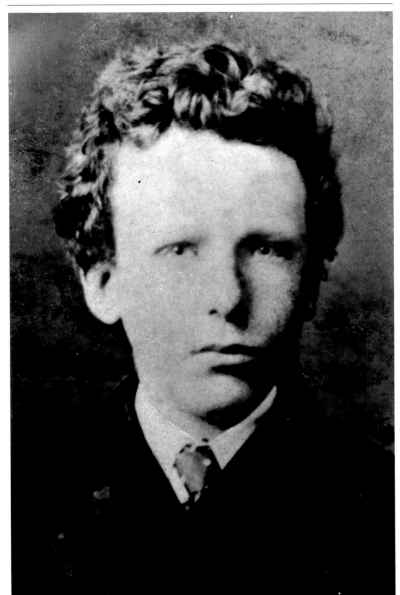

The inhabitants of the presbytery in Groot-Zundert, the Netherlands, spent 30 March 1853 in fervent prayer. Anna Cornelia Carbentus, the wife of the pastor, Theodorus van Gogh, was about to give birth. On that same date one year earlier, she had given birth to a stillborn child, Vincent Willem. The child born on this day was given exactly the same name: Vincent Willem van Gogh.

CHAPTER I

UNCERTAINTY AND SOLITUDE

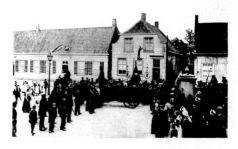

At age thirteen (left), Vincent was a mediocre pupil and a solitary boarder. At right is the house in North Brabant in which he was born.

The name Vincent had existed in the van Gogh family since as early as the end of the seventeenth century. Vincent was named for his grandfather, a pastor in Breda, who had been born in 1789, and his Uncle "Cent." Uncle Cent owned a shop in the center of The Hague, at Number 14 on the Plaats, from which he sold prints and modern paintings. He was a "supplier to the Chambers of Their Majesties, the King and Queen" of Holland. His brothers Hendrick (Uncle Hein) and Cornelis (Uncle Cor) were also art dealers. Of the six brothers, only Theodorus was a pastor, like their father had been. Unfortunately, Theodorus did not inherit his father's eloquence. He was already twenty-seven when, on 1 April 1849, he was appointed pastor of Groot-Zundert, a village in North Brabant, in the Netherlands near the Belgian frontier. A moderate and evangelical Calvinist, he was not in sympathy with either of the rival orthodox or modernist Calvinists, and his parish consisted of only about one hundred people.

In 1851 the Reverend van Gogh had married Anna Cornelia Carbentus (called Moe), whose father was a bookbinder at the court. Vincent was their oldest child. In 1855 Moe gave birth to a daughter, Anna Cornelia; just as the girl was given her mother's name, the son who was born on 1 May 1857 was christened after his father, Theodorus, and called Theo. Three more children were born in the presbytery at Groot-Zundert: Elizabeth Huberta, born in 1859, Wilhemina Jacoba, in 1862, and Cornelis Vincent, in 1867.

Vincent was a quiet, solitary child who liked to roam the countryside. At the parish school of Groot-Zundert, he learned to read, write, and count

On 1 October 1864 his father, Pa, sent Vincent as a boarder to a school run by Jean Provily in Zevenbergen. He was by himself for the first time in his life: "Standing on the steps, beside Mr. Provily, I watched our carriage disappear on the wet road." Vincent studied French, English, and German, but he was a poor scholar. He was sent next to the Hannik Institute in Tilburg, but by mid-March 1868, the Reverend van Gogh, whose financial situation had become precarious, could no longer pay for

Theodorus van Gogh, Vincent's father, was a modest preacher who always held only minor positions.

Vincent's mother, Anna Cornelia Carbentus.

This drawing by Vincent, dated 8 February 1864, was the birthday present he gave his father that day. He was only eleven years old at the time.

boarding school. Vincent returned to Groot-Zundert, his studies finished at the age of fifteen.

Uncle Cent had sold his business because of illness and retired to Princenhage, near Breda. Goupil and Co., a firm that had its headquarters in Paris, in the Rue Chaptal, as well as two galleries, one on the Boulevard Montmartre, the other on the Place de l'Opéra, had made Uncle Cent's shop its Dutch branch. Goupil and Co. also had galleries in London and Brussels. On 30 July 1869 Mr. Tersteeg, the manager of the Dutch branch, took young Vincent on as a seller of prints and engravings on the strength of his uncle's recommendation.

Few drawings by Vincent from his childhood exist, and they generally do not give any indication of the genius he would later become. This one, however, dated 11 January 1862, is so remarkable for a child of nine years that its authenticity was questioned for some time.

Vincent van Gogh was a keen, punctual, and efficient employee. He was a model worker who attracted nothing but praise

Vincent led a well-ordered, simple, and studious life, which included reading and visiting the museums. In 1872 he left The Hague for the summer and went back to stay with his family, who had moved at the end of January 1871 to Helvoirt, where his father had been appointed pastor. Theo, who was studying nearby at Oisterwijk, joined them there. Their father continued to have financial difficulties at Helvoirt, which made it impossible for Theo to go on with his studies. The two brothers left their father's presbytery together; Theo accompanied Vincent to The Hague, where Vincent was boarding with the Roos family. A few days later Theo went back to Oisterwijk, and the two brothers began to write to each other.

In mid-December Pa informed Vincent that, once again with the help of Uncle Cent, Theo had been given a job at Goupil and Co. He would begin working at their gallery in Brussels at the beginning of 1873. Vincent wrote to his brother, "I am so glad that we shall both be in the same profession and in the same firm. We must be sure to write to each other regularly." During the next seventeen years their correspondence was interrupted only three times. The first break was from August 1874 to February 1875, which were months of uncertainty, anxiety, and change for Vincent. The second was from October 1879 to July 1880; Vincent refused to write to a brother who did not approve of what he was doing and who told him so. The third time was from March 1886 to February 1888, when Vincent was living with his brother in Paris.

In January 1873 Goupil and Co. raised Vincent's salary. Two months later he was transferred to their

When he was eighteen (above), Vincent drew the pond of the Royal Court in The Hague (right), where he lived in the early 1870s. The strict education he had received made him an upright and scrupulous young man.

The Hague was the capital of a prosperous and industrious kingdom. William III had reigned in the Netherlands since 1859, and his loyalty to the principles of parliamentary government inspired great respect for his dynasty. Social peace in this kingdom was achieved, as in the rest of Europe, at the cost of the poverty and misfortune of those whom progress, that god of the nineteenth century, had forgotten.

gallery in London, which sold only to dealers. He moved there in June, after a trip to Paris lasting a few days, during which time he visited the Salon, the Louvre, and the Musée du Luxembourg. Settling in London posed no problems for Vincent. He was pleased to have more time to himself than he had had in The Hague. He had only one reservation: The lodgings he had taken, in a suburb of London, were for him very expensive—eighteen shillings a week, not including laundry. And although the Germans who were staying in the same house were pleasant companions, given to laughter and singing, they nevertheless spent money freely when they went on walks together. Vincent could not keep up with them and soon looked for more modest accommodations.

In London, Vincent discovered English painting. He remarked that he was "getting used to it"

He read Keats, visited the parks, rowed on the Thames. He discovered John Constable—"a landscape painter who lived about thirty years ago; he is splendid; his work reminds me of [Narcisse] Diaz and [Charles-François] Daubigny"—as well as Joshua Reynolds, Thomas Gainsborough, and J.M.W. Turner. His work selling engraved reproductions such as Jean-Auguste-Dominique Ingres' *Venus Anadyomene*, colored photographs sold in tinfoil frames, and scrapbooks used to display photographs continued to fascinate him. In London, Goupil and Co. was "his" business. The letters he wrote to Theo, in Brussels and later in The Hague, when his brother took up his position at the gallery managed by Mr. Tersteeg, were also business letters, giving pieces of information, details of methods of employ, and pieces of advice: "Try to take as many walks as you can and keep your love of nature, for that is the true way to learn to understand art more and more. Painters understand nature and love her and *teach* us to see her." The young man who wrote these words did not yet think of painting for himself. At twenty years of age, "having nothing yet

*V*enus Anadyomene is inscribed strangely: "J. Ingres made this during 1808 and 1848." It was completed forty years after it was begun.

possessing all," he felt that he was becoming "a cosmopolite" and, above all, a man.

Vincent was in love. Since August 1873 he had been living at the house of Madame Loyer, the widow of a pastor from the South of France. She ran a small school in London and was bringing up her nineteen-year-old daughter, Ursula. Sometime before his departure for Holland, Vincent asked for Ursula's hand in marriage. She declined, revealing that she had become engaged secretly. Vincent had been rejected, and it was a disappointed, bewildered, and distraught son that Pa and Moe saw back at Helvoirt. He did not write a word about this wound to his brother. However, his comments on historian Jules Michelet's book *L'Amour*, which he recommended to Theo, broke this silence: "And that man and wife can be one, that is to say, one whole and not two halves, yes, I believe that too."

During his second stay in London, in the winter of 1874–75, Vincent experienced long weeks of depression

He returned to London and moved into Ivy Cottage, 395 Kensington New Road. Anna, his nineteen-year-old

Vincent's view of London was not of the solemn ceremonies of Queen Victoria, who had reigned over the United Kingdom and her empire since 1837, but of the slums, of overcrowding, promiscuity, and squalor. Thrift, Character, Duty, the cornerstones of the Victorian outlook, did not affect the poor masses to whom Vincent spoke.

sister, accompanied him. She was looking for a job as a teacher, governess, or lady's companion, "and at all events I think there is more chance for her to find something here than in Holland." For several weeks, Anna was his sole companion. Nothing interested Vincent anymore: "Since I have been back in England, my love for drawing has stopped, but perhaps I will take it up again some day or other." He no longer took an interest even in the shop and did not appear to have any concern at all for the future of Goupil and Co.: "Probably we are going to move on 1 January 1875,

In Paris (shown here in a view by Corot), Vincent discovered French painters he would never forget. In 1885 he wrote to Theo: "Delacroix, Millet, Corot, Dupré, Daubigny, Breton, and thirty others, do they not make up the heart of the century in terms of pictorial art?"

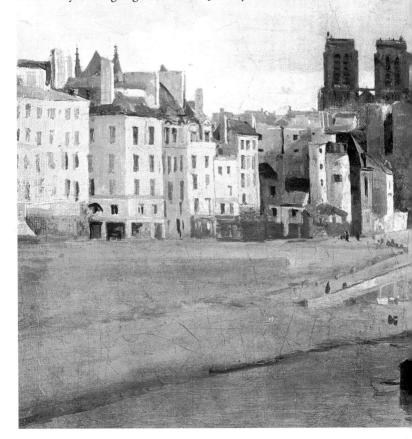

to another, larger shop." As for his sister, "I think it will be very difficult to find anything for her."

Two months later, Vincent copied a few sentences by French scholar Joseph Ernest Renan in a postscript to one of his letters to Theo: "To act well in this world one must sacrifice all personal desires. Man is not on this earth merely to be happy, nor even simply to be honest. He is there to realize great things for humanity, to attain nobility and to surmount the vulgarity of nearly every individual." This could have been an epigraph to the story of van Gogh's life; however, nobody, not even Vincent himself, was aware of that yet.

6

GOUPIL & Cⁱᵉ
Éditeurs Imprimeurs
ESTAMPES FRANÇAISES & ÉTRANGÈRES
Tableaux Modernes
RUE CHAPTAL, 9, PARIS.
Succursales à la Haye, Londres, Berlin, New-York.

Paris, le 24 Juli 1875

Waarde Theo,

Een paar dagen geleden kregen wij een Sch?
van de Nittis, een gezicht in London op een
regendag, Westminster bridge & the house of
Parliament. Ik ging elken morgen & avond
over Westminsterbridge & weet hoe dat er uit
ziet als de zon achter Westminster abbey &
the house of Parliament ondergaat & hoe het

In the spring of 1875 Vincent was transferred to the headquarters of Goupil and Co., in Paris

In mid-May Vincent arrived in Paris and rented a room in Montmartre. Neither his visit to the Corot exhibition (the painter had died a few weeks earlier) nor his visits to the Louvre and the Luxembourg could dispel the mysticism that was beginning to obsess him. The letters that he wrote at the time are catalogues—a list of prints pinned up on the walls of his room, a list of poems he was reading at the time. In every one of these letters he takes every opportunity to evoke the Bible and to cite psalms and verses. On Sundays Vincent went to the church at which a Reverend Bersier preached and then

Between August 1872 and July 1890, 668 letters by Vincent began with the words "Dear Theo." Written in Dutch, English, and French, they constitute a long meditation on painting, its purposes, and its demands.

went on to the Louvre or to the Luxembourg. He continued to live like this, attending church services and looking at pictures, for another few months. At the end of September 1875, he wrote to Theo, "Don't take things that don't really concern you very closely *too* much to heart, and don't let them hit you too hard." This piece of advice was, in fact, addressed to himself. He cared only about God. Without telling anyone in the management of Goupil and Co., at the end of December Vincent left Paris for the village of Etten, near Breda, where Theodorus van Gogh had become pastor at the end of October. Upon his return, after the Christmas holidays, Vincent discovered that his employment with Goupil and Co. was to be terminated: "When I saw Mr. Boussod again, I asked him if he approved of my being employed in the house for another year and said that I hoped he had no serious complaints against me. But the latter was indeed the case, and in the end he forced me, as it were, to say that I would leave on the first of April."

Obsessed by mysticism and by God, attracted by religion, Vincent left both the Goupil firm and France

After his resignation Vincent answered a few advertisements that appeared in English newspapers. He received his only reply on his twenty-third birthday, which coincided with the very morning of his departure for Etten. Mr. Stokes, a teacher in Ramsgate, invited Vincent to spend a probationary month, without pay, at his school.

After spending two weeks with Pa and Moe in Etten, on 16 April 1876, Vincent arrived in Ramsgate and found Mr. Stokes' school, which his twenty-three-year-old son, a schoolmaster in London, was in charge of while his father was away. Also present was an assistant

On 4 November 1876, Vincent preached for the first time in this church (above) near the house of the Reverend Jones, the Methodist minister (below).

teacher, seventeen years old, who supervised the twenty-four boys, ranging in age from ten to fourteen years, enrolled at the school. Vincent taught "elementary" French, as he reported to his brother Theo, as well as basics such as arithmetic and spelling. He was also asked to supervise the boys' washing and dressing in the "room with the rotten floor. It has six washbasins in which they have to wash themselves; a dim light filters onto the washstand through a window with broken panes." For this dull work, Vincent received only "board and lodging," and he was allowed only a few free hours in which he could give private lessons. Vincent needed something entirely different. In mid-June he went to London to meet with a Protestant minister to whom he had written, "But as my aim is a situation in connection with the Church, I must look for something else." In Isleworth, a working-class suburb of London to which Mr. Stokes had transferred his school at the beginning of July, Vincent continued his search.

This drawing (left), which illustrates a letter to Theo, shows what Vincent saw from one of the classrooms of Mr. Stokes' school in Ramsgate.

Vincent was convinced that he could not work in any capacity other than that of a schoolmaster, pastor, or missionary

He wanted "to sow the words of the Bible" among the poor and the working class. Mr. Stokes continued not to pay him. Vincent traveled regularly to London and knocked on the doors of ministers, pastors, priests. At other times, he visited museums. At Hampton Court he saw the works of Rembrandt, the Hans Holbeins, and the Bellinis: "It was a pleasure to see pictures again." He soon left Mr. Stokes and joined a school in the same suburb of Isleworth, at Holme Court, run by a Reverend Jones. Just before the school year began, Vincent decorated the refectory with holly to spell out the words Welcome Home. He read and reread the Bible, the Acts of the Apostles, and the Letters of St. Paul. One question

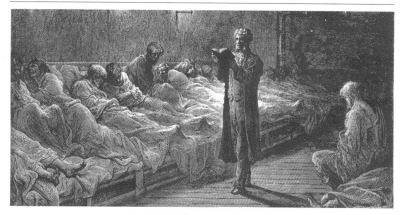

he contemplated, "Who shall deliver me from the body of this death?" evokes a sermon given by the Reverend Bersier in Paris, as well as Pa's sermon, which he had heard a few months earlier at Etten, and suggests an oppressive sense of dread.

At the beginning of October, Vincent, whose services were not being solicited by any minister in London, was relieved of some of his teaching obligations by Mr. Jones, who was aware of his employee's talent as a preacher and asked him to visit the people of the parish.

On Sunday, 4 November 1876, in Mr. Jones' church, Vincent delivered his first sermon, in English

Vincent's sermon ended with a description of "a very beautiful picture: It was a landscape at evening. In the distance on the right a row of hills appeared blue in the evening mist. Above those hills [shone] the splendor of the sunset, the gray clouds with their linings of silver and gold and purple. The landscape itself was a heath covered with grass and yellow leaves, for it was autumn." Yet it was not painting that Vincent

"The other day I saw a complete set of [Gustave] Doré's pictures of London (above and below). I tell you it is superb and noble in sentiment—for instance that room in the *Night Shelter for Beggars.*"
To Anthon van Rappard
September 1882

was thinking of as he preached: "When I was standing in the pulpit I felt like someone who, emerging from a dark cave underground, comes back to the friendly daylight."

At Isleworth Vincent's working days were long. Every morning he gave the boys lessons until 1 P.M., then helped Mr. Jones or substituted for him. Later he gave private lessons, leaving the evening and night in which to prepare and write his sermons. One of Vincent's duties was to take charge of the Sunday school at Turnham Green. He preached to the poorest people: "Tomorrow I must be in the two remotest parts of London: in Whitechapel—the very poor part that you have read about in Dickens; and then across the Thames in a little steamer and from there to Lewisham."

The last letter that Vincent sent Theo a few days before Christmas 1876 was, in fact, a long sermon. In it he wrote of the Lord, who appeared to him: "There exists a friend whose embrace is even closer than that of a brother."

Vincent returned to Etten, exhausted and gaunt but enlightened. Pa and Moe were worried and persuaded him not to go back to England. Thanks to Uncle Cent's intervention, a Mr. Braat agreed to employ Vincent as a clerk in his bookstore, Van Blussé and Van Braam, in Dordrecht. At the end of January he arrived there, resigning himself to the job. "I shall be very busy," he wrote. His lodgings were at the home of Mr. Rijken, a grain and flour merchant. On the walls of his room he hung religious prints: *Christ the Consolator, Supper at Emmaus, The Sorrowful Mother,* and *The Imitation of Jesus Christ.* Every morning by 8 A.M. he was at the bookstore; he sometimes stayed there until midnight or 1 A.M.

Vincent would sit at his desk and copy out page after page of the Bible, drafting translations of it into English, German, and French: "I read it daily, but I should like to know it by heart and to view life in the light of its words." Theo was beginning to worry about his brother. Vincent was forgetting to come down to dinner at his landlord's and was staying awake for entire nights. At the bookstore he constantly read the Bible. Mr. Braat put up with this out of deference to the Reverend van Gogh, of

Supper at Emmaus, 1648, by Rembrandt, whose work Vincent admired intensely. In Vincent's eyes Rembrandt was almost a proof of the existence of God, since whoever looked at his paintings could have no doubt that there was a God: "Besides, he always remains noble, of a truly great nobility, of infinite elevation. And yet Rembrandt was also able to do something more when he didn't feel obliged to be literally faithful to nature, as was expected in portraits, when he was able to work on a poetic level and be a poet, that is, a creator."

In the margin of a letter from November 1876, Vincent used his pen to draw the churches of Petersham and Turnham Green in Isleworth.

whose straitened circumstances he was aware, and out of respect for Vincent, who now had only one goal: "It is my fervent prayer and desire that the spirit of my father and grandfather may rest upon me, that it may be given me to become a Christian and a Christian laborer."

Vincent went to Amsterdam to see his uncles Cor and Stricker. His determination finally convinced them to allow him to undertake the studies necessary to become "a preacher of the Gospel."

In Amsterdam Vincent labored over his studies. In July 1877 he wrote to his brother: "Greek lessons in the heart of Amsterdam, in the heart of the Jewish quarter (left), on a close and sultry summer afternoon, with the feeling that many difficult examinations await you, arranged by very learned and shrewd professors.... They make one feel more suffocated than the Brabant cornfields."

Back in Holland, Vincent became firmly convinced of his destiny

A few days after his return to Etten, he wrote to Theo, "There are days when I think what a marvelous thing it is that we are again walking on the same land and that we are speaking the same language." Later he repeated, "While walking on that dyke, I said to myself, How good the soil of Holland is."

On his twenty-fourth birthday Vincent made a strange pilgrimage. Alone, he took the last train from Dordrecht to Oudenbosch. From there, he went on foot to Groot-Zundert: "It was very early when I arrived at the churchyard in Zundert; everything was so quiet. I went over all the dear old spots, and the little paths, and waited for the sunrise there." Certain that he was destined to preach the word of God, Vincent left Dordrecht with the intention of becoming a pastor.

The Deposition, 1633, by Rembrandt was inspired by Peter Paul Rubens' painting of the same subject. Unlike Rubens, however, Rembrandt did not feel at all obliged to give his characters a classical beauty; he painted them with a realism that was almost crude, which was precisely the feature van Gogh admired in Rembrandt's work.

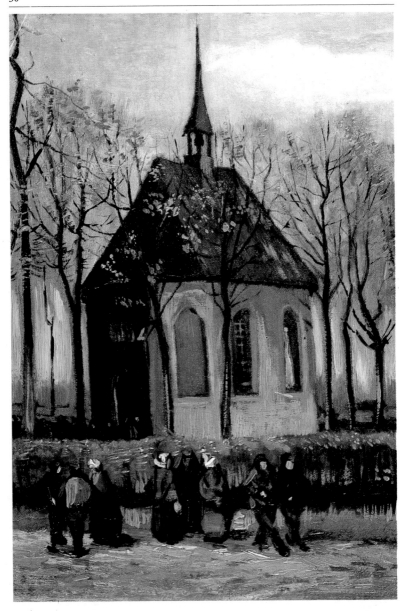

His faith had won. Vincent van Gogh was to be a pastor, like his father and grandfather. He still had to take the entrance examination to the Faculty of Theology in Amsterdam, and he was faced with long and arduous studies, which the Reverend Theodorus van Gogh was not in a position to pay for, in spite of his devotion to his son. Since Vincent's vocation made it clear that a family tradition had to be respected, his uncles rallied around him. In Amsterdam they welcomed him and gave him help and advice.

CHAPTER II
APOSTLESHIP
AND DRAWING

Chapel at Nuenen with Churchgoers (left), January 1884. Theo (right), born on 1 May 1857, in Groot-Zundert, was more than Vincent's only brother; it was he who, by his ever-loyal support, enabled Vincent and his work to exist.

Uncle Jan (Johannes), who was the director of the naval shipyards in Amsterdam, was a widower. He made a room in his house available to Vincent. Uncle Stricker, his mother's brother and a pastor, supervised and encouraged him. Uncle Cor (Cornelis) ran an art gallery in Leidenstraat, and Vincent visited him regularly. A few days after his arrival, at the beginning of May 1877, Vincent obtained from Uncle Cor several reams of old paper, on which he began to write out his first Greek and Latin exercises. Vincent was not perturbed either by the amount or the difficulty of the work he had to do to prepare for the theology examination. He knew he had to work unrelentingly. A sentence of Camille Corot's became his guiding principle: "It took only forty years of hard work, thought, and attention." When he strolled through certain sections of Amsterdam, his thoughts turned to Rembrandt: "It always reminds me of Rembrandt's etchings." In fact, his points of reference were all painters; in one letter after another, to describe landscapes or faces he had observed, he constantly cited Jacob van Ruisdael, Willem Maris, Bertel Thorvaldsen, Jules Goupil, Charles de Groux, Daubigny, and others.

In the margins of an etching by Rembrandt, Vincent noted the words "*In medio noctis vim suam lux exerit*" (In the middle of the night light spreads its power)

This epigraph encouraged him to stay awake at night. He worked all night long by the light of a small gaslight, though his uncle had expressly forbidden him to do this.

Vincent worked away stubbornly. Suddenly, doubts began to confuse and worry him: "I don't see how I shall ever get that difficult and extensive study into [my head]." But he pulled himself together. Mendès da Costa, a doctor his Uncle Stricker had introduced him to, gave him Greek and Latin lessons. The room in which Mendès received him, in the heart of the Jewish quarter, was stiflingly hot in summer. In mid-August, Uncle Stricker, for whom Vincent had great respect ("he is very clever and possesses a great many fine books; he loves his work and his profession deeply"), questioned him about his studies and found his answers satisfactory.

In 1827 Uncle Johannes, an admiral who had recently lost his wife, was living alone in a large empty house near the naval dockyards. All his children were grown and had left home; thus he could take his nephew in, thereby allowing him to prepare for his examination at the Theological Faculty.

The summer went by, followed by autumn. Uncle Stricker maintained his high expectations and his vigilance. He may have half-suspected, when he questioned Vincent again, that his nephew's work was less than satisfactory. Vincent admitted that he found the task very difficult but reassured his uncle that he was doing his best. Mendès, whom Vincent took as his model ("I consult Mendès in everything"), said nothing. Vincent kept silent about the fact that whenever he realized that his work was inadequate, he beat himself with sticks, bruising his back. He even made himself sleep outside on the coldest nights.

Vincent made no progress in algebra or geometry. Mendès introduced him to one of his nephews, Teixeira de Mattos, a teacher at the Jewish school and the school of the poor, who gave Vincent basic lessons in algebra and geometry. These subjects, and the history and geography of Greece, Asia Minor, and Italy, filled up his time and cut him off from the essential work, "the study of theology itself and exercises in elocution." The weeks went by and Vincent studied hard.

"It is costing me more and more effort. I find it difficult to work.... I must work.... My life depends on it; it is nothing less than a struggle for my existence"

Did Vincent really want to enter the Theological Faculty, which he considered to be "an incredible institution, a blend of culture and pharisaism"? In these months that were to determine his fate, he regularly went back to the Trippenhuis to look at Rembrandt's *Syndics of the Drapers' Guild*. In his letters to Theo he urges his

This landscape drawing of the countryside near Amsterdam, which, according to Vincent, was "a doodle," accompanied a long letter to Theo dated 3 April 1878.

brother to get to know their cousin Anton Mauve, who was a painter.

Vincent drew "instinctively, as I am writing, I sometimes do a little drawing.... It is nothing special, but it sometimes appears in my mind so distinctly, so clearly." In a letter dated 4 December 1877, he alludes to Uncle Hein, who had just passed away at the age of sixty-three: "We must thank God that the end was comparatively calm and that he is at rest at last." That was all he said about it. A few days earlier, he had learned of the death of the painter Gustave Brion, and a few weeks later he was to hear that Daubigny had died. The deaths of these painters affected him more than that of his uncle, "for the work of such men, if well understood, touches more deeply than one is aware. It must be good to die conscious of having performed some real good, and knowing that by this work one will live, at least in the memory of some, and will leave a good example to those who come after."

For the moment, Vincent was not leaving a good example to anyone at all. The results of the examinations for which he had been preparing for fifteen months were negative.

In October 1878 Vincent van Gogh was refused admittance to the Theological Faculty of Amsterdam

And yet, neither the disappointment nor the humiliation of being rejected weakened his resolve. His life had to be the life of a pastor, and that is what it would be in spite of this setback, about which he remained silent. He left for Etten. Mr. Jones, the Methodist minister for whom Vincent had worked in Isleworth and who had given him the chance to preach for the first time, was traveling through Holland. He agreed to accompany Vincent and his father to Brussels, where he knew the Reverend Bokma, the director of the Flemish evangelical school. The course at the school was much less expensive than the one in Holland, and it took only three years instead of six. Vincent was given to understand that he could be sent out on a mission before the completion of his studies. Unfortunately, it was out of the question for him to be able to spend three months in Brussels before

"But just as the morning hour is blessed and is worth much gold, so first impressions keep their value even though they pass, for sometimes they prove to have been right after all and one comes back to them."

To Theo
May 1878

Sunset by Charles-François Daubigny, one of the few painters whose open-air technique influenced the young artists of their time, who, from the time of their first exhibition, were labeled Impressionists. Daubigny painted on board his boat, the *Botin,* on which he sailed untiringly, with paintbrush in hand, along the banks of the Seine. He worked for a long time with Camille Corot before allowing himself to be influenced by Gustave Courbet. Daubigny was one of the first artists to attempt to capture on canvas the transience of the moment.

the course began, as he wanted to do; it would have been too costly. It was therefore decided that he would work in Etten and make regular visits to the Reverend Pietersen in Mechlin and the Reverend de Jonge in Brussels.

As soon as he returned to Etten, Vincent prepared a few essays: "I am writing one now on Rembrandt's picture *The House of the Carpenter* in the Louvre." Vincent was thinking not of painting but of evangelism. Was there really that big a difference between the two? Among the things that are "food for the true life," Vincent mentions great art: "For this is what great art does, and the works of those who apply themselves heart, mind, and soul—as do many whom you know and perhaps meet personally, whose words and deeds are full of spirit and life."

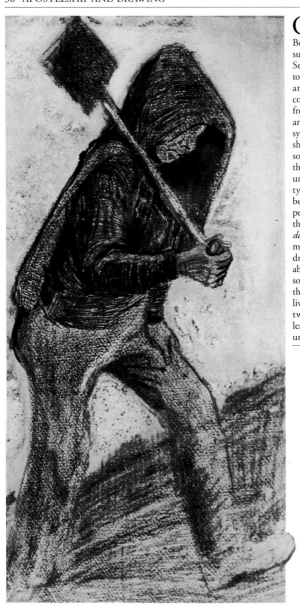

Coal Shoveler, drawn by Vincent in the Borinage during the summer of 1879. On 24 September 1880 he wrote to Theo: "The miners and the weavers still constitute a race apart from other laborers and artisans, and I feel a great sympathy for them. I should be very happy if someday I could draw them, so that those unknown or little-known types would be brought before the eyes of the people. The man from the depth of the abyss, *de profundis*—that is the miner; the other, with his dreamy air, somewhat absentminded, almost a somnambulist—that is the weaver. I have been living among them for two years and have learned a little of their unique character."

The Reverend de Jonge asked Vincent to return to Brussels shortly before the end of August. He entered the novitiate of the school at Lacken, near Brussels. For three months Vincent earnestly attempted to achieve what was expected of him, but he failed to do so. "He did not know the meaning of submission," one of his fellow students recalled. His independence, his inability to conform to expectations, as well as his sudden outbursts of anger, were considered by his teachers to be sufficient grounds for refusing to grant him the title of evangelist. However, these were not the reasons that Mr. de Jonge and Mr. Bokma alluded to when they informed him, on 15 November, that even though his training had not yet been completed, they could not keep him on at the school any longer according to the terms that were granted to Flemish students. His only option was to leave, yet there could be no question of his returning to Etten.

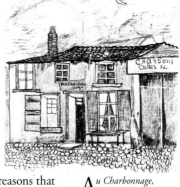

Au Charbonnage, November 1878. Situated near a towpath, this tavern, as drawn by Vincent, was frequented by coal miners.

At the beginning of the winter of 1878 Vincent left for the Borinage "to preach the Gospel to the poor and to all those who needed it" and teach

All that Vincent knew about the region of Hainaut, between Mons and the French border, was the description he had read of it in a geography textbook.

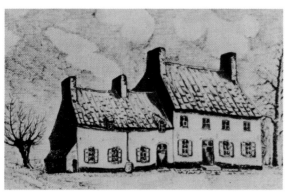

Vincent stayed at the house of the miner Charles Decrucq, shown in this anonymous drawing.

He stayed at 39 Rue de l'Eglise, in Pâturages, at the house of a door-to-door salesman named van du Haegen. He paid for his keep by giving lessons to the salesman's children in the evenings. All day long he visited the sick and preached the Gospel to the miners. Instead of allowing Vincent, who was not subject to any authority at all, to continue his apostleship, the committee of the evangelical school in Brussels reacted to this *fait accompli* by giving him the post of "lay evangelist" in nearby Wasmes for the next six months. Vincent saw the poverty of the miners of the Borinage as similar to that of the men and women of the East End of London, but "with miners one must have a miner's character and temperament, and no pretentious pride or mastery, or one will never get along with them or gain their confidence." Vincent therefore left his comfortable lodgings with the local baker, Jean-Baptiste Denis, and moved into a shack, where he slept on straw.

In the coal mines of the Borinage Vincent wanted to be a poor man among the poor

He went down into the mine: "One goes down in a kind of basket or cage, like a bucket in a well, but in a well from 500 to 700 meters [550 to 770 yards] deep, so that when looking upward from the bottom, the daylight is about the size of a star in the sky."

In Wasmes painting was nothing more than a memory for Vincent: "Don't forget that I still just about understand when you write to me about painting, even though it has been a long time since I have seen any pictures. Here in the Borinage there aren't any pictures; generally speaking, people here don't even know what a picture is." Among the miners, who were the victims of poisoned air, gas explosions, seepage of underground water, and the collapse of old galleries, Vincent wrote, "Most of the miners are thin and pale from fever; they look tired and emaciated, weather-beaten and aged before their time."

When Pa came to see him in March, Vincent resembled the miners. He soothed and dressed their wounds and prayed with them. Yet he continued to see as an artist. From a hill near Wasmes, he looked

The Return of the Miners, the Borinage, April 1881. The overwhelming misery that Vincent has shown here was not simply a motif; it is what he saw every day in the name of the Gospel.

across the valley, toward the horizon: "Generally there is a kind of haze hanging over it all, or a fantastic chiaroscuro effect formed by the shadows of the clouds, reminding one of pictures by Rembrandt or Michel or Ruisdael." When he encountered a foreman, Vincent again compared him to a picture: "When I met him for the first time, I thought of the etching by [Jean-Louis-Ernest] Meissonier that we know so well, *The Reader*."

It was not this gaze obsessed by painting that the evangelical school in Brussels reproached him for, but his self-denial and his hotheadedness. His fanatical zeal,

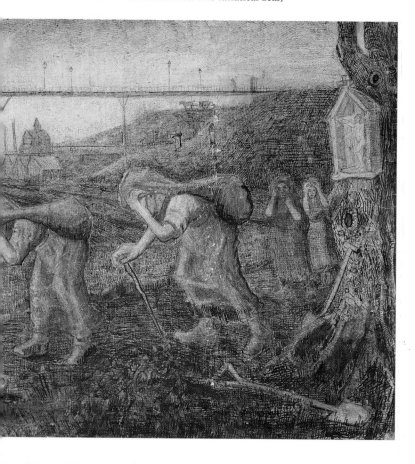

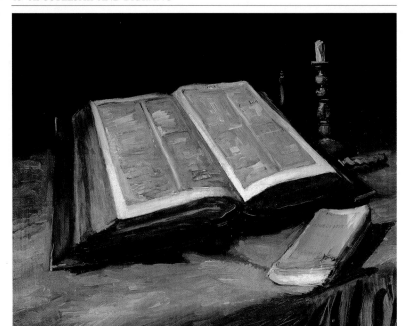

which made him defy conventions, was unacceptable to the school committee.

At the end of July 1879, therefore, Vincent's contract was not renewed. Furious, he left Wasmes for Brussels on foot, without waiting for any explanation or reversal of the decision.

Distraught, Vincent needed advice. He turned to the Reverend Pietersen, but they talked more of painting than preaching. The reverend painted "in the manner of [Lodewijk] Schelfhout or [Johannes] Hoppenbrouwers." Vincent showed him a few of his drawings: "He asked me for one of my sketches, a miner type."

He was glad to confide in Theo: "I often draw far into the night, to keep some souvenir and to strengthen the thoughts raised involuntarily by the aspect of things here." He wrote again to his brother: "In Brussels I bought from a Jewish book dealer another big sketchbook of old Dutch paper."

Still Life with Bible, October 1885. Vincent wrote to Theo at this time: "In answer to your description of the study by Manet, I send you a still life of an open…Bible bound in leather against a black background, with a yellow-brown foreground and also a touch of citron yellow. I painted that all at once, on one day."

In August 1879, rejected by the Church, which criticized him for his excessive commitment, Vincent took lodgings at the house of Mr. Frank, an evangelist who lived in Cuesmes

Vincent moved to Cuesmes, near Mons, in order to pursue the evangelization of the poor he had begun in Wasmes, but now he worked without the approval of any church.

Vincent was alone—condemned and despised. No one could put up with his stubborn and unflinching obstinacy, and, in fact, he did not wish to hear anything from others. At the beginning of October, Theo, the spokesman of the van Gogh family, passed through Cuesmes. Vincent had been silent for two months. He gave no answer to the questions Theo now asked him, and Theo's arguments, entreaties, and orders did nothing to dent his intransigence. Vincent wanted to go on with his evangelical work even though he did not have a diploma from any faculty, a title conferred by a church, or any money. The Old and New Testaments took the place of diplomas and he was consecrated by his faith. As for money, he could appeal for charity. Theo's visit did not shake Vincent's resolve; he would not resume his studies: "How fresh my memory of that time in Amsterdam is. You were there yourself, so you know how things were planned and discussed, argued and considered, talked over with wisdom, with the best intentions, and yet how miserable the result was.... How desirable and attractive have become the difficult days, full of care, here in this poor country, in these uncivilized surroundings compared to that." By way of a decisive argument, Vincent declared, "I have sometimes had a lesson from a German reaper that was of more use to me than one in Greek."

Theo attempted in vain to convince his brother of the need to learn a trade, whatever it might be—that of a printer of bills or visiting cards, of a bookkeeper, a carpenter, baker, barber, or librarian. Although Vincent was upset by the idea that his brother suspected he wanted others to provide for him, he attempted to exonerate himself: "May I observe that this is a rather

"A prisoner who is condemned to loneliness, who would not be allowed to walk, etc., would in the long run, especially if it lasted too long, suffer from the consequences as certainly as a man who fasted too long. Like everyone else, I feel the need of family and friendships, of affection, of friendly intercourse; I am not made of stone or iron, like a hydrant or a lamppost, so I cannot miss these things without being conscious of a void and feeling a lack of something, like any other intelligent and decent man. I tell you this to let you know how much good your visit has done me. And just as I hope that we two shall not be estranged from each other, I hope the same may be true in regard to all at home. But for the moment I do not feel very much like going back there, and I am strongly inclined to stay here.**"**

To Theo
15 October 1879

strange sort of 'idleness.'... If I had to believe that I were troublesome to you or to the people at home, or were in your way, of no good to anyone, and if I should be obliged to feel like an intruder or an outcast, so that I were better off dead, and if I should have to try to keep out of your way more and more—if I thought this were really the case, a feeling of anguish would overwhelm me, and I should have to struggle against despair.... If it were indeed so then I might wish that I had not much longer to live."

At the risk of appearing to be a parasite, Vincent did not give up his course of evangelism

Since he could not agree to give up that life, Vincent would not accept reproaches or condemnations: "Do you think a person is wrong to remain indifferent before a picture catalogued as a [Hans] Memling but having nothing to do with Memling—except that it is a similar subject from the Gothic period but without any artistic

Calling the Gleaners Home, in the Artois Region, by Jules Breton, Courrières, 1859. Breton was an important reference point for Vincent in that he painted subjects of work, especially rural labor, instead of the subjects from ancient history or mythology favored by other painters.

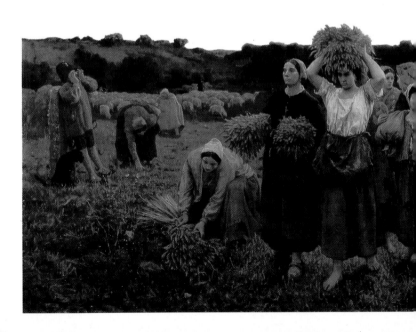

value?" This self-justification failed to convince Theo. In spite of everything, Vincent did not want to have harsh words with his brother. When Theo chided him, Vincent remained silent for nine months.

Starved, abandoned by all, Vincent's only income now consisted of the few francs his father sent him. It was, in fact, Theo who was sending this money without his brother's knowing about it. In July 1880 while visiting Etten, Vincent learned that Theo had just sent him a money order for 50 francs. When he returned to the Borinage Vincent wrote to him. As he had spoken in French with the miners of the Borinage for several months, and as Theo was now working in Paris, Vincent wrote in French: "Involuntarily, I have become more or less a kind of impossible and suspect personage in the family.... I am a man of passions, capable of and subject to doing more or less foolish things, for which I happen to repent, more or less, afterward.... One of the reasons why I am unemployed now, why I have been

In order to prove to Theo that he was drawing all the time, Vincent copied sketches into his letters to him.

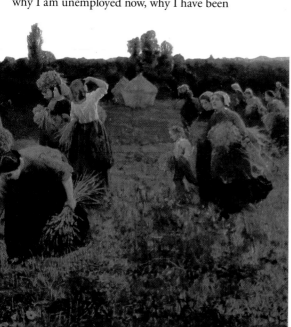

unemployed for years, is simply that I have different ideas from the gentlemen who give the places to men who think as they do."

A single phrase, in this very long letter, is underlined: "for even now, *far from that land, I am often homesick for the land of pictures.*" This acute homesickness for the land of pictures was part of his apostleship. His passion for painting did not mean that he was giving up religion.

"How can I be useful, of what service can I be? There is something inside of me, what can it be?"

"To give you an example: someone loves Rembrandt, but seriously—that man will know there is a God, he will surely believe it." This vitally important letter was a confession of impotence and a cry for help. On his own Vincent could not get the better of what was hampering him: "One cannot always tell what it is that keeps us shut in, confines us, seems to bury us; nevertheless, one feels certain barriers, certain gates, certain walls.... Do you know what frees one from this captivity? It is every deep, serious affection. Being friends, being brothers, love, that is what opens the prison by some supreme power, by some magic force. Without this, one remains in prison." Theo was not troubled by the fact that this passage was still marked by the tone of the sermons Vincent had preached; he offered Vincent his support. In return, toward the end of August 1880, Vincent wrote to Theo only of drawings: "If I can only continue to work, somehow or other it will set me right again." Theo sent him

prints, which he copied. He studied the figure drawings of masters such as Jean-François Millet, Jules Breton, Gustave Brion, or A. B. Boughton and continued his own drawing. Mr. Tersteeg, who was still the director of Goupil and Co.'s gallery in The Hague, where Vincent had worked ten years earlier, sent him Charles Bargue's handbook on drawing as well as books on anatomy and

"I have sketched a drawing representing miners, men and women, going to the shaft in the morning through the snow, by a path along a thorn hedge: passing shadows, dimly visible in the twilight. In the background the large mine buildings stand out vaguely against the sky."
To Theo
20 August 1880

perspective. He studied these with the same zeal with which he had read, translated, and commented on the Bible. His models were the miners and weavers in whose midst he had been living for two years. They were "types that had still not been portrayed" in painting.

It was by the daily practice of drawing that Vincent began to reemerge from the "mess" he had allowed himself to sink into

Apart from the novelty of his subject, Vincent realized that drawing was becoming his salvation: "I cannot tell you how happy I am to have taken up drawing again.... Though I feel my weakness and my painful dependence in many things, I have recovered my mental balance, and day by day my energy increases." In order to keep this balance, he had to leave Cuesmes and the Borinage. Although drawing got the better of his apostleship, "I hope I shall be able to make some drawings with something human in them."

These male and female miners, whom Vincent drew over and over again, were also the models for Emile Zola, who began to write his novel *Germinal* only a few years after Vincent's stay in the Borinage.

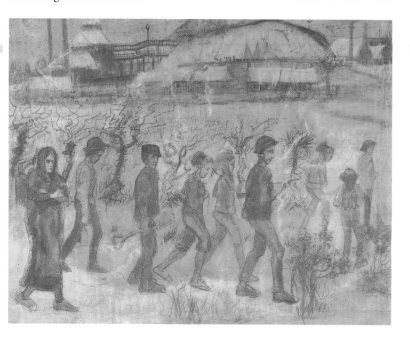

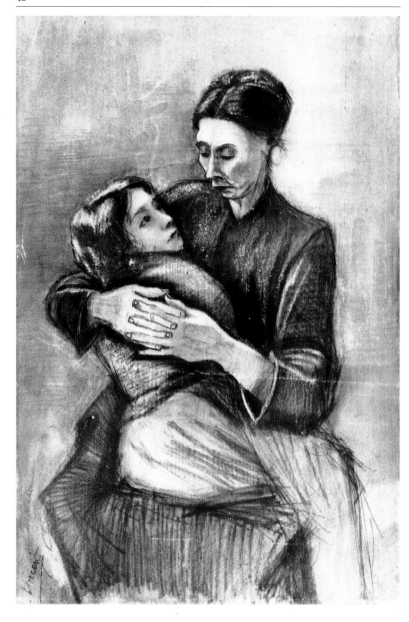

Octuber 1880, Brussels. Vincent was twenty-seven years old. He paid a call on Mr. Schmidt, the director of the Brussels branch of Goupil and Co., and asked him to introduce him to a few artists. Mr. Schmidt received this former employee of the Goupil firm cordially but doubted whether Vincent could, at such a late stage, begin a career as an artist.

FIGURES AND POVERTY

"It seems to me that I have put together a palette that is practical and made up of healthy colors."

Vincent's drawing of an artist's palette, 1882 (above). *Mother and Child*, 1883 (left).

Vincent did not know anything about drawing from classical models, about anatomy, or about perspective. Mr. Schmidt suggested that the indecisive young man, who had experienced one failure after another, should register as a student at the Académie des Beaux-Arts in Brussels. Vincent, for his part, did not believe that the traditional methods of teaching at the academy would suit him. He was also afraid that the professors, the "academicians," might resemble those of the evangelical school, whom he considered hypocrites and pharisees. Vincent wanted to be able to work by himself with an artist and to learn from him "the laws of proportion, of light and shadow, of perspective," all the knowledge that he considered necessary. But he doubted whether plaster casts of Greek and Roman statues could enable him to acquire some essential "capital of anatomy."

A few months earlier, in Paris, Theo had met a young painter, Anthon van Rappard. Five years younger than Vincent, van Rappard was studying in Brussels. Vincent went to see him in his studio in the Rue Traversière. The two young men had very little in common. The noble van Rappard was rich; Vincent was poverty stricken. The room Vincent had moved into, at 72 Boulevard du Midi, cost him 50 francs, for which he also received some bread and a cup of black coffee in the morning, at midday, and in the evening. Theo sent him 60 francs every month, which thus left Vincent 10 francs to pay for his drawing materials, models, books, food, and clothing: "The expenses here will be somewhat more than 60 francs, which cannot be helped."

Vincent believed that the sooner he learned to draw, the sooner he could earn his living in London or Paris

"For a good draftsman finds work easily today; they are very much in demand and it is possible to get a well-paid position." Therefore, he kept working hard. After a few weeks, during which each artist studied the other, van Rappard the aristocrat and van Gogh the wanderer were working together on a regular basis. Van Rappard taught van Gogh perspective and lent him anatomical plates.

At the beginning of May 1881 van Rappard told Vincent that he would shortly leave Brussels. What was

Anthon G. A. van Rappard (below) shared Vincent's passion for painting, at least until the day when the latter could no longer bear the nobleman's criticisms.

"It will *not* be so easy to confound me as they think, despite all my faults. I know too well what my ultimate goal is, and I am too firmly convinced of being on the right road, after all, when I want to paint what I feel and feel what I paint, to pay much attention to what people say of me."
To van Rappard
August 1885

orse, Vincent had no money to go on living there. Mr.
ersteeg, the director of the Goupil gallery in The
Hague, suspected Vincent of wanting to live off his
ncles, and his uncles, like his parents, accused him of
wanting to live like a person of independent means. Only
Theo came to his assistance; he spent a few days in Etten,
efending his brother's case. In April Vincent joined him
here, exhausted, hungry, and dressed in rags. His velvet

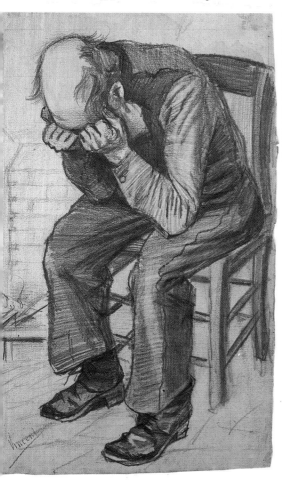

For a long time,
Vincent did not paint
portraits but painted only
what he called "figures":
men and women who did
not pose for their features
but for a gesture, an
attitude, most often
associated with work.
This *Old Man with His
Head in His Hands,*
1882, is a portrait not of
a man but of his despair.

suits were worn and patched; they made him look like a bum. His father was not at all reassured by the fact that "these were the kinds of clothes that were worn in the studios."

In spite of the misunderstandings and the anxieties, which did not disappear, Vincent was treated like the prodigal son who had come home. He was allowed to work freely in the presbytery for some time, and he took up his studies again there. Van Rappard came to work with him, and every day they went out to draw on the heath, at the edge of a marsh. When van Rappard left twelve days later, Vincent began studying watercolor. Up until then he had used only a pencil for his drawings. He was now just beginning to shade and to finish his drawings with a reed pen, which produced thicker lines. He also made copies—of twenty wood engravings by or after Millet, which he had brought back with him from Brussels, and after the drawings by Holbein reproduced in Bargue's drawing handbook.

Mr. Tersteeg, of the Goupil gallery.

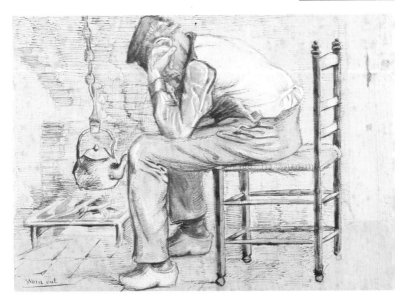

Worn out

In August he spent two days in The Hague. Mr. Tersteeg and Vincent's cousin Anton Mauve, to whom he showed his studies, both thought that he had made progress. Vincent wrote to Theo that Mauve wanted him to start painting. He visited another painter, Théophile de Bock, who, even though he was convinced that Vincent had the temperament of a painter, advised him to draw more figures.

Vincent incorporated these drawings of workers within the body of a letter he wrote to Theo in October 1881.

On his way back to Etten, Vincent passed through Dordrecht solely in order to draw a row of windmills, and upon his return, he began drawing figures again. For Vincent, drawing implied learning to concentrate: "Diggers, sowers, planters, male and female, they are what I must draw continually. I have to observe and draw everything that belongs to country life."

He drew continually; by mid-October he was still at it. In a letter to Anthon van Rappard, he reported: "I have all kinds of studies of diggers, sowers, etc., men and women. At present I am working a good deal with charcoal and black crayon, and I have also tried sepia and watercolor. Well, I do not venture to say that you will see progress in my drawings, but most certainly you will see a change."

Vincent knew that he was making progress, but this progress also prompted some apprehension. He wrote to Theo: "Before long I hope to be able to pay another visit to Mauve to discuss with him the question of whether I should start painting or not. Once started, I shall carry it through. But I want to talk it over with some people before starting." After years of doubt, exile, and failure, Vincent was beginning, for the very first time in his life, to understand himself.

Worn Out (left), a drawing in pencil enhanced with watercolor, once belonged to van Rappard. Here Vincent has drawn an "old sick peasant, sitting on a chair in front of the hearth."

The passionate love he felt for a woman infused Vincent's work with an intensified energy

In August 1881 Vincent's Uncle Stricker sent his daughter, Kee Vos-Stricker, who was known as Kate, to spend a few weeks of the summer with his sister and brother-in-law. Kate had been widowed recently and had a daughter who was slightly older than Vincent. Meeting Kate had an overwhelming effect on the young man: "Since I met her, I get on much better with my work." Vincent made a declaration of love to her but she rejected him. Still mourning the loss of her husband, she was unable to reciprocate Vincent's feelings for her. He persisted. "No, never, never," was Kate's reply. Vincent remembered his previous rejection, an experience that had marked him deeply. Bitter, misogynistic, he had, for years, repeatedly asserted, "Woman is just man's desolation." But now, he preferred to repeat a sentence of Michelet's: "A woman must breathe on you for you to be a man."

Kate had by now returned to Amsterdam, and Vincent pestered her with letters, to which she did not reply. His uncle and parents grew impatient with this relentless pursuit. They considered his attitude tactless and inappropriate. In a fury, Vincent followed Kate to Amsterdam.

He found the Reverend Stricker's house on the Keizersgracht and rang the doorbell unannounced. The family was at the dinner table; only Kate was away. Vincent demanded that his aunt and uncle tell him where she was. By way of a reply, his uncle read Vincent a letter stating clearly that Kate's refusal was final and that he should stop harassing her. Vincent then held his hand over an oil lamp and, with his hand in the flame, demanded to see Kate. This attempt was futile and produced nothing but a painful burn.

Disappointed in love for the second time, Vincent turned to painting

He left Amsterdam at the beginning of December. At The Hague, he knocked on Mauve's door and reminded his cousin that he had once suggested that Vincent could

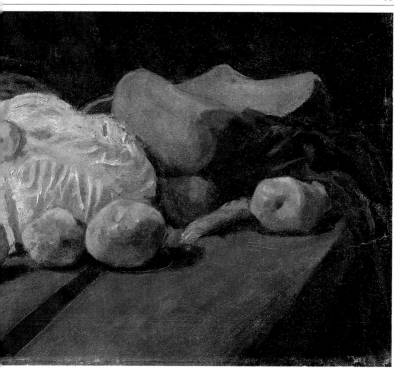

Still Life with Cabbage and Clogs, November 1881. Vincent painted this in Anton Mauve's studio in the course of one of his lessons with his cousin. This is the very first oil painting van Gogh made. At the same time, he continued to make drawings of laborers (left).

come to Etten and be initiated into the mysteries of painting. Vincent asked Mauve's permission to stay with him for a few weeks and showed him some studies he had drawn.

The very next day, Mauve sat him down "before a still life with a pair of old wooden shoes and some other objects." Holding a palette, in a studio for the first time in his life, Vincent was painting beside a painter. Mauve looked at Vincent's still life: "I always thought you rather dull, but now I see it isn't true." The decisive step had been taken: Vincent was to be a painter.

He rented a room for 30 florins a month, including breakfast, ten minutes from Mauve's house, outside the city at 138 Schenkweg. He had a room, an alcove, and a window with a southern exposure that was "twice as large as an ordinary window." He had to make do with the

100 francs that Theo sent him every month. He returned
briefly to Etten to collect his clothes and drawings and
had yet another quarrel with Pa. On Christmas Day
Vincent had refused to go to church. He told his father
that he thought religion was horrible, that he wanted to
stay clear of it "as of something fatal." Pa ordered him to
leave the house. He returned to The Hague, going back
not only to Mauve but also to a woman he had met there
after he had resigned himself to the loss of Kate. She was
one of the unfortunates whom he thought of as his
"sisters in circumstances and experience," a prostitute he
had come to know "from need of vital warmth and for
hygienic reasons." Her name was Clasina Maria
Hoornik; her nickname was Sien, but Vincent called her
Christine. She was thirty-two years old, pregnant, an
alcoholic, and had syphilis. But she bore some
resemblance to "some curious figure by [Jean-Baptiste]
Chardin or [Edouard] Frère, or perhaps Jan Steen." It
was this portrait that Vincent was bringing into his life.

A nton Mauve, one of
the leaders of The
Hague School.

The advice of the painter Mauve and the reassuring presence of a woman by his side reinforced Vincent's determination to paint

Mauve gave Vincent a box of paints, some brushes, and a
palette and lent him the 100 florins he needed to set
himself up. He urged Vincent to replace his patched and
stained clothes, which made it impossible for him to be
introduced to anyone, and encouraged him to do
watercolors. Vincent searched for models: Sien was one.
Whenever he couldn't find a model, he drew in cheap
restaurants, in pawnbrokers' shops, or in third-class
waiting rooms. Mauve regularly gave him lessons.
Relations were, however, sometimes strained between the
two painters. Vincent did not react to criticism any
better than Mauve did. He had come to know other
painters: de Bock, Willem Maris, Georg-Hendrik
Breitner, Johannes Weissenbruch. Only the latter
appreciated Vincent's work. He told Tersteeg about it,
and Tersteeg bought a small drawing for 10 florins. But
van Gogh's relations with others were subject to change.
He could not accept that anyone could have the slightest
reservation about his work. Any qualification was an

insult, any criticism a condemnation. This led to disagreements, bad feeling, and lawsuits.

Gradually, models came to pose more regularly for Vincent. He drew: "I work, I drudge, I grind all day long." What little money he had went to the models. In March his Uncle Cornelis commissioned him to do a series of twelve pen-and-ink drawings, views of The Hague. Vincent asked for 2.50 florins for each of these and thus received 30 florins he had not counted on. But landscapes were not what he liked doing best: "Whenever I paint landscapes, they always smack of figures." He was obsessed by the figure. He asked his models to assume not academic poses but those of diggers and seamstresses.

F*ishing Boat on the Beach near Scheveningen,* by Anton Mauve, 1876. Vincent also regularly drew and painted boats on the sand and fishermen on this beach near The Hague.

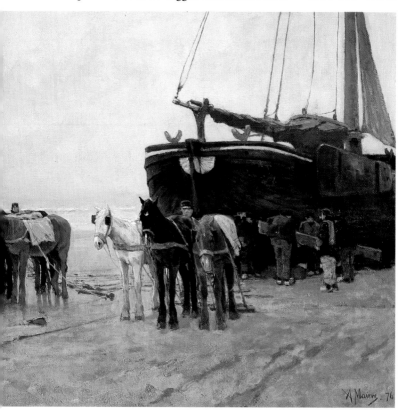

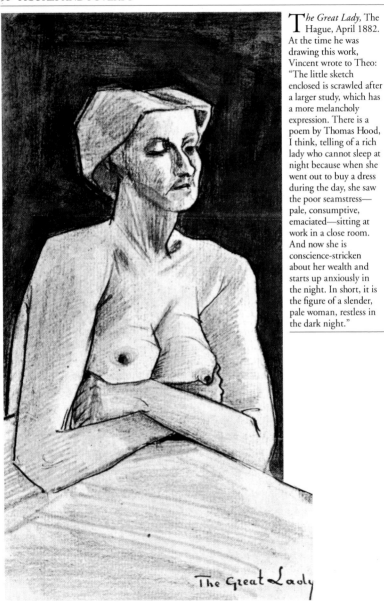

The Great Lady, The Hague, April 1882. At the time he was drawing this work, Vincent wrote to Theo: "The little sketch enclosed is scrawled after a larger study, which has a more melancholy expression. There is a poem by Thomas Hood, I think, telling of a rich lady who cannot sleep at night because when she went out to buy a dress during the day, she saw the poor seamstress—pale, consumptive, emaciated—sitting at work in a close room. And now she is conscience-stricken about her wealth and starts up anxiously in the night. In short, it is the figure of a slender, pale woman, restless in the dark night."

He worked to understand perspective and to capture the reality of movement. Sien continued to pose for him. She was the model for *The Great Lady,* a woman tormented by her conscience, and for *Sorrow,* an icon of despair. In April 1882 he realized that since he had been in The Hague, "Every week I now do something which I couldn't do before."

Vincent's wretched physical condition, the intransigence of his opinions, and his inner demands destroyed his social relationships

Vincent had not seen Tersteeg for weeks. Mauve had refused to see him for more than two months; they had quarreled over whether to copy plaster casts. Vincent lamented his situation. "Because I shall have to suffer much, especially from the peculiarities which I *cannot* change. First, my appearance and my way of speaking and my clothes; and then, even later on when I earn more, I shall always move in a different sphere from most painters because my conception of things, the subjects I want to make, inexorably demand it."

Vincent was well aware of the fact that painting was all-important in his life. He had to respect his craft as a painter and his own morality: "I do my best; I draw, not to annoy people, but to amuse them, or to make them see things that are worth observing and that not everybody knows."

Vincent gave the most demanding definition of painting. It was a process of initiation. He had to make visible that which could not be seen without painting.

This *Female Torso* (left) was one of the classical plaster casts found in all the academies at the time. Vincent's refusal to draw these casts, despite Mauve's insistence, caused the breakup of their friendship, yet in 1886 he would make the above studies from plaster casts.

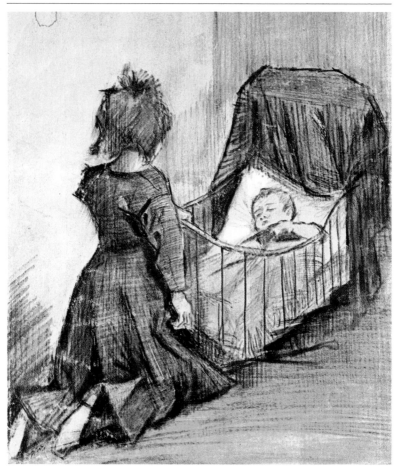

At the end of April, a storm blew out the window of his studio, scattering his drawings and overturning his easel. The damage gave Vincent a pretext to move. The house next door had two stories, and his studio would be larger there. The rent was only 12.50 florins. He could move and set up a home. Vincent wrote to Theo, telling him that he wanted to marry Sien "secretly, without any fuss," as soon as he got back from Leiden, where she was to give birth. She was neither a burden nor a millstone

around his neck but a companion. And without him she was undoubtedly destined for doom. Having no resource other than the money Theo regularly sent him, Vincent was afraid that his brother would not agree to the marriage and would cut off his assistance, which would have been "a death sentence."

A few days after informing Theo of his urgent wish to marry Sien, Vincent wrote him that he was feverish, nervous, and could not sleep. He went outside to draw at 4 A.M. because "this is also the finest moment to see the main outlines, when everything is in tone." By the end of May he had spent all the money Theo had sent him and could not even pay for a stamp to put on the card he sent his brother to ask for his help. If Vincent did not pay his rent on 1 June, he would be evicted. The money Theo sent arrived in time and the rent was paid, but Vincent's family had been told that he was living with a prostitute. They considered establishing a board of guardians to exert authority over him.

Having been reprimanded and feeling depressed and exhausted, Vincent was admitted to the City Hospital in The Hague on 7 June 1882, as patient number nine, in ward six, in fourth class

"It seems that I really have what they call the 'clap.'" The window of the ward he was placed in looked out onto "a bird's-eye view, which, especially in the evenings and in the mornings, is mysterious because of the light's effect, for instance, like a Ruisdael or van der Meer [Jan Vermeer]. But I may not and cannot draw it as long as I am so weak." He also wrote, "The doctor is exactly as I should wish: He looks like some heads by Rembrandt."

The doctor's actions prompted Vincent to think of the practice of painting: "I shall try to handle my models the way he does his patients, namely by getting a firm hold on them and putting them straightway into the required position." He stayed in the hospital twenty-three days.

Shortly after being discharged, Vincent went back to Leiden. Sien had had a son in what had been a difficult birth. At her bedside, happy to be with her again and to see the newborn child with his "worldly wise air," Vincent's thoughts were nevertheless somber: "Only the

Vincent was fascinated by Sien's children, a five-year-old daughter called Maria Wilhelmina and little Willem, born 2 July 1882. In March 1883 Vincent drew the little girl kneeling in front of the baby's cradle (left). The presence of the children made one of his lifelong dreams come true. That summer he wrote to his brother: "A studio in which there is a cradle and a child's chair. A studio in which there is no stagnation, but where everything impels, incites, and stimulates one to work. My apartment is clean, cheerful, bright, and gay; I have most of the necessary pieces of furniture, bedding, and the artist's materials I need. It cost what it cost, but…that money enabled me to set up a new studio that cannot do without your help just yet, but out of which more and more drawings can now emerge."

gloomy shadow is threatening still—master Albrecht Dürer knew it well enough when he placed Death behind the young couple in that beautiful etching you know." Beside the child's cradle, he felt "the eternal poetry of the Christmas night with the baby in the stable—as the old Dutch painters saw it, and Millet and Breton."

Back in The Hague Vincent set up "a studio in which there is no stagnation, but where everything impels, incites, and stimulates one to work." And yet, people had

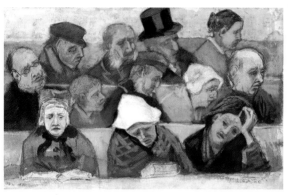

Sorrow (right), drawn in 1882, portrays a female nude, with her face hidden and breasts and stomach distorted. It is a portrait of Sien, the woman who was rejected by Vincent's family and whom he was unable to rescue by himself. It was not a detail of social realism that Vincent made here, but a symbol, a myth. *Sorrow* assumed in its creator's imaginary universe a place comparable to that of Albrecht Dürer's *Melancholia.*

Church Pew with Worshipers, October 1882 (left). The faces of the faithful, to whom Vincent wanted to preach, became his models.

their doubts about him. Tersteeg was not alone when he told Vincent that he "was a fool and everything [he] did was wrong." Theo was the only one who continued to believe in him. Vincent awaited his brother's visit impatiently but warned him, "My dress is a little too Robinson Crusoe–like for paying calls with you." Theo asked Vincent to give up the idea of marrying Sien. If he wanted to paint, so be it; Theo would give him the means to paint. He wanted to talk only about the painter Vincent was becoming and wanted to hear of nothing other than painting. Vincent stopped talking of marriage and showed Theo the layout of his palette and the way he was using a perspective frame he had made.

"While painting, I feel a power of color in me that I did not possess before"

"Painting harnesses infinity." Vincent's doubts, his worries were concerned only with painting. His joy in

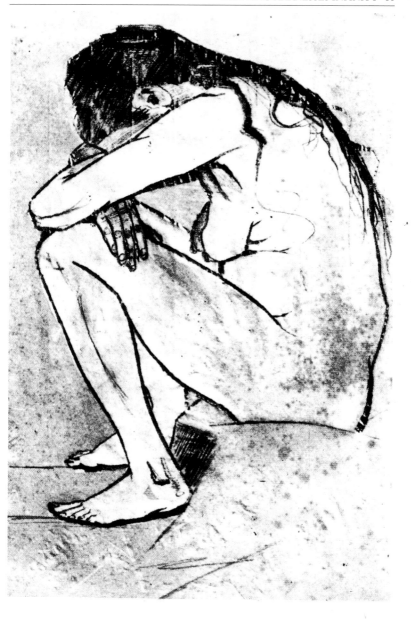

painting consumed him: "In a word, it is more gratifying than drawing."

In November 1882 Vincent had prints made of his first lithograph and sent the first proof to Theo. These first attempts at printmaking encouraged him to imagine, as "a matter of duty and of charity," the establishment of a noncommercial society for the distribution of works of art for the people. For the first time he entertained the possibility that his work might become well known: "I don't think it improbable that sometime I shall make things that will come into the public's hands, but it leaves me rather cold and I don't consider it a pleasure at all." Nevertheless, when a dealer who saw the lithograph *Sorrow* asked for a set of prints to be made especially for him, Vincent felt a genuine pleasure. Even this pleasure did not weaken his belief that a painter could never be truly happy: "One must struggle with oneself, make oneself more perfect, and renew one's energy, and, in addition to those difficulties, there are material difficulties to be overcome." Through his friendship with the young painter Johannes van der Weele, Vincent found once again the comradeship in research that he had not experienced since his break with Mauve.

The determined zeal with which he worked could not overcome Vincent's episodes of depression caused by financial worries

Relentless work only depressed him further. At the beginning of February 1883, he was again very weak, which surprised him: "Sometimes I cannot believe I am only thirty years old, I feel so much older."

The ailment went away. Months passed: "The most important thing is to go on, to persevere." Once again Vincent was drawing figures. He gradually amassed a complete collection, since 1870, of the journal *Graphic*. He was tremendously impressed by the reproductions published in it, and it became a veritable Bible for him.

Vincent's only regret was that he could not work more because he could not pay for models. He went regularly to Scheveningen to draw the fishermen. The scenes he saw on the beach—the dunes—as well as the ideas of van Rappard, with whom he continued to correspond,

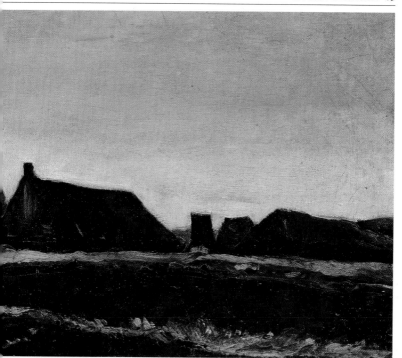

encouraged him to begin larger drawings, which required him to consider something he had never really dared to tackle before, composition.

Once again Theo asked Vincent to leave Sien. She had been unfaithful to him, but Vincent had misgivings: Abandoning her to her fate would mean throwing her back into prostitution. Despite his despondency, he could not agree to it. They spoke of Drenthe, which van Rappard had told Vincent could be a great source of inspiration. Initially he thought of going there with Sien, but her continuing

In Drenthe Vincent sought scenes from nature, such as these *Farms*, painted in September 1883 (above), as well as this fisherman and this woman on the beach (left), whom he painted a month earlier.

infidelity finally became unbearable to him: "Going to Drenthe is the best solution, both for my work and in order to reduce my expenses." Painting won the day: "I am troubled by a great sadness because of the woman and children, but there is no other possible solution." On 11 September 1883 he moved into an inn in Hoogeveen run by Albertus Hartsuiker.

Drenthe was a flat region of peatbogs, open fields, heather, and canals. Here was yet more poverty

Every day, Vincent went out to draw, but he was plagued

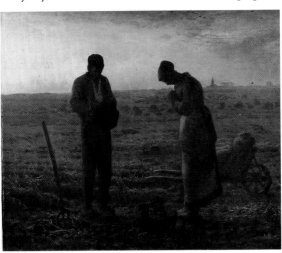

The Angelus (below left), painted in 1857 by Jean-François Millet.

"Millet is *father Millet*—that is, a guide and counselor to the young painters in all things. As for myself, I agree with him and believe what he says implicitly."
To Theo, April 1885

by disenchantment, remorse, and sadness. He reproached himself for having abandoned his partner and her children and accused himself of being incapable of having a normal relationship with anyone. He considered the facilities available to him "too miserable, too inadequate, too dilapidated." Then, once again, he became consumed by painting, although he knew what faced him. Painting went "together with trouble, worries, disappointments, hours of melancholy, impotence, and all that." To improve Vincent's spirits, Theo suggested that Vincent join him in Paris. He refused and in turn suggested that Theo should turn to painting and come out to join him. Weren't the Ostades,

the van Eycks, the Bretons all painters and brothers? But Theo neither wanted nor was able to leave Paris.

Vincent could not stay in Drenthe any longer. He went back to the family presbytery in Nuenen. The aftertaste of failure was the same as ever, as were the arguments with Pa and Moe. It seemed to him that his role in the family was that of "a big rough dog [who] would run into the room with wet paws."

He stayed, however. With some reluctance, his parents gave him a room, which he made into his studio. He was not asked to pay for his keep so that he could pay off his

Two Women Working in the Peat, October 1883. Vincent's stay in Drenthe was marked by a perceptible darkening of his palette. It was his aim to paint the very people who did not know what a painting was, and to paint for them.

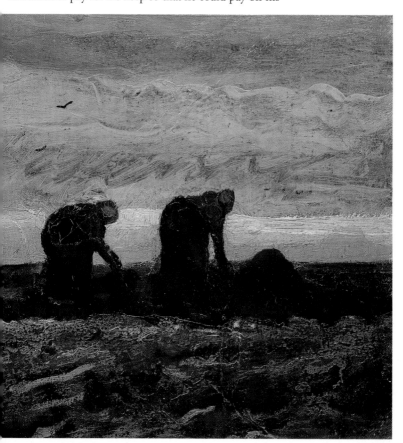

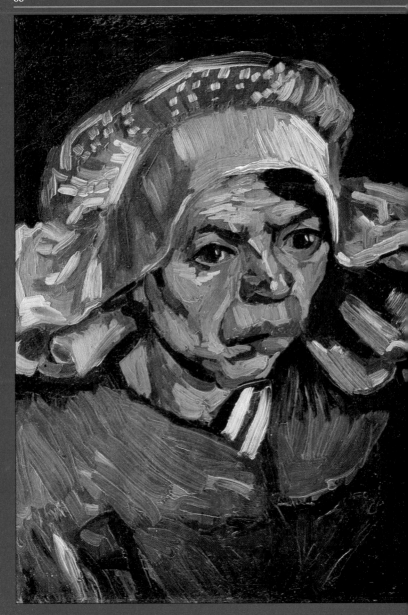

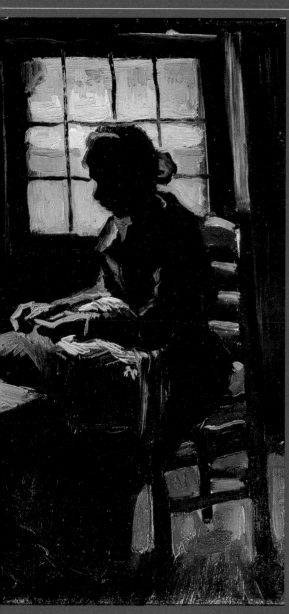

Peasant Woman, Head, 1885 (far left), and *Peasant Woman, Sewing,* 1885 (left). One day, when he went out to work in the open air, Vincent walked past the small house of a peasant family. He went in to rest for a moment; they were all gathered around the table, getting ready for their meal. Vincent had a mysterious illuminating flash. He had already been overwhelmed by the miners of the Borinage, by the "ordinary" human tragedy in all its simplicity. He immediately set to work on the subject that obsessed him: the ordinary working people.

"I propose to start this week on the canvas representing a group of countryfolk around a dishful of potatoes, in the evening—or possibly in the daylight—or both at once—or neither one, as you will say. I may succeed and then again I may not; be that as it may, I shall start to do some sketches of the different figures."

To Theo
April 1885

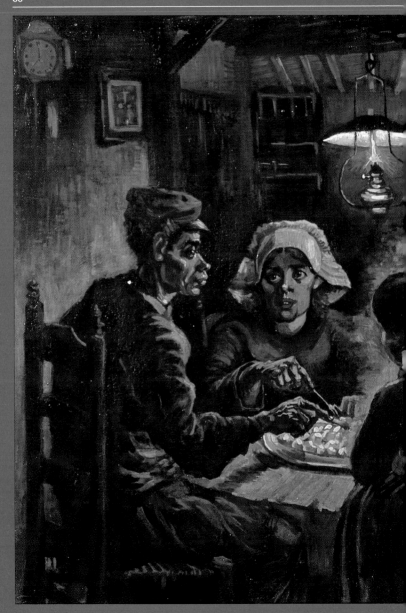

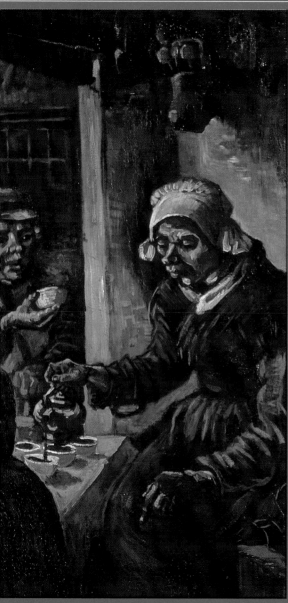

From the first sketch of *The Potato Eaters,* Vincent fixed the main points of his investigation: to emphasize the nuances of the dark interior of the cottage, to make the darkness tangible in the same spirit that his masters Rembrandt and Hals had achieved.

"I have tried to emphasize that these people, eating their potatoes in the lamplight, have dug the earth with those same hands they put in the dish, and so it speaks of manual labor and of how they have honestly earned their food."

To Theo
April 1885

debts. Embittered as he was, he could not put up with Theo's criticism. A quarrel was brewing. He began to draw weavers, a new subject for him.

When Mr. Hermans, a goldsmith in Eindhoven, asked him to decorate his dining room, Vincent sketched six scenes of farm work—including potato planters, a sower, a laborer, and a group of peasants loaded down with firewood—as well as a picture of the goldsmith, who was more than sixty years old. The money he received barely covered the cost of the frames, canvases, and paints.

One day, in October 1884, Vincent realized that his work had restored his good spirits

Van Rappard was back in Nuenen. Vincent was giving painting lessons there. The man who sold him his paints in Eindhoven had introduced him to some people who had become his students. One was a postal employee, William van der Wakker; another was the son of a lithographer, Dimmen Gestel; yet another, Anthon Kerssemakers, was a tanner.

In December Vincent gave up the subjects he had been painting for months. He now only wanted to paint heads and aimed to paint about fifty of them during the winter. He wanted his painting to be "in real life," in the manner of those whom he considered his masters. Color was not one of his concerns.

On 26 March 1885 the Reverend Theodorus van Gogh died of an apoplectic stroke at the front door of the presbytery. Vincent's grief was profound, in spite of the long series of misunderstandings that had marked his relations with his father. A few weeks later he moved into the house of the sexton, where he already had his studio. All he wanted was "to live in the heart of the country and to paint the lives of the peasants." It was at this time that he began work on "the canvas representing a group of countryfolk around a dish full of potatoes."

"What joy to see such a Frans Hals, how different it is from those pictures—there are so many of them—where everything has been carefully smoothed down in the same way."

In fact, it was not this *Happy Drinker* (detail, above) that Vincent had seen in Amsterdam, but a similar painting by Hals. Left: Drawing of a reaper, 1885.

The Potato Eaters, painted when Vincent was thirty-two years old, was his first large-scale composition. He sent the picture to Theo in Paris.

For a few years now, there had been talk in Paris of the scandalous paintings produced by the Impressionists. Living in Nuenen, however, Vincent knew little of what their painting was like, "But I do know who the original and most important masters are, around whom, as around an axis, the landscape and peasant painters will revolve: [Eugène] Delacroix, Corot, Millet, and the rest."

"There is, on the face of it, nothing simpler than to paint peasants, ragmen, and ordinary workmen, but nothing, no subject at all in the art of painting is as difficult as those simple characters"

Vincent sent van Rappard a lithograph of the first version he had done of *The Potato Eaters*. Van Rappard's comments were very critical, and Vincent rejected them.

"Whether depicting figures or landscapes, painters have always had a tendency to want to prove to people that a picture is something other than a reflection of

"When I call myself a peasant-painter, it is a real fact, and it will become more and more clear to you in the future that I feel at home there. And it was not in vain that I spent so many evenings at the houses of the miners, and peat cutters, and weavers, musing by the fire, except when I was too hard at work for musing."

To Theo
April 1885

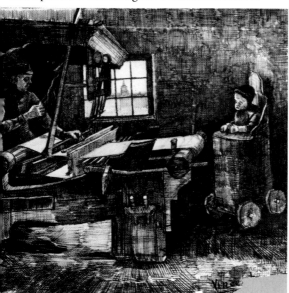

The painting *Quay with Ships*, 1885 (left), depicts the bend in the Scheldt, near Antwerp, below the Royers lock. Vincent was not yet very concerned about color; his palette was still dull and gray. Another example of this is *Houses Seen from the Back*, in Antwerp (right). However, it was from this period on that, imperceptibly at first, Vincent's palette began to grow brighter. From his window he painted the backs of the old houses with such bright colors that J.-B. de la Faille, the author of the catalogue raisonné of Vincent's complete works, made the mistake of assuming that this picture dated from his Parisian period. After the somber tones of *The Potato Eaters*, Vincent gradually felt an increasingly urgent need to turn to brighter colors.

nature in a mirror, something other than an imitation, a copy, and that it is, on the contrary, a re-creation." In order to achieve this himself, Vincent knew that the means at his disposal in Nuenen were inadequate. In November 1885 he left for Antwerp, although he was not enthusiastic about the place: "It will probably prove to be like everything everywhere, namely disillusioning."

Vincent was impressed by Rubens and asked to have his technique explained to him

The work of Flemish artist Peter Paul Rubens "is so very simple, or rather seems to be so. His means are so simple, and he paints, and particularly draws, with such a quick hand and without any hesitation." This was a decisive lesson. In January 1886 Vincent registered at the Ecole des Beaux-Arts in Antwerp. He took the drawing courses of Messrs. Verlat and Vink and even drew from plaster casts. He also took painting classes and spent the evenings in a club, with a companion named Siberdt, drawing and working from models until 11:30 P.M. His body, however, could not stand the pressure of his frenetic life-style.

On 18 February 1886 he wrote: "There are still ten days left in the month, and how am I to get through them? For I have absolutely *nothing* left." Before the end of that month, Vincent had left Antwerp.

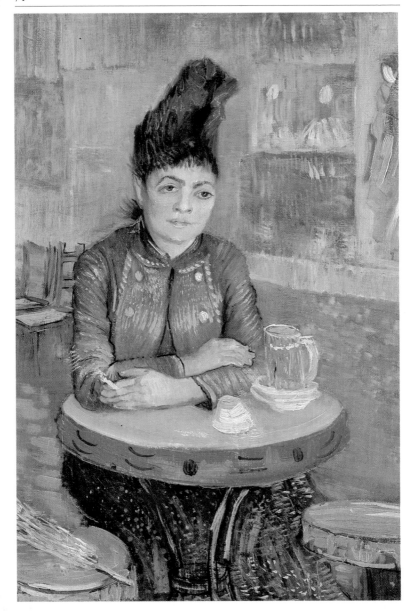

On 20 February 1886 Theo van Gogh received a note from Vincent at Goupil–Boussod and Valadon on the Boulevard Montmartre. His older brother had just arrived in Paris and wanted to meet in the Salon Carré in the Louvre: "Please let me know at what time you could come." Vincent had hastened his arrival in Paris for two reasons: He was convinced that by living with his brother he would be able to save some money, and he wanted to join the studio of Fernand-Anne Piestre, known as Cormon.

CHAPTER IV
COLORS AND EXILE

At the inn Le Tambourin, Vincent painted his friend Agostina Segatori (left). He himself was Emile Bernard's model (right).

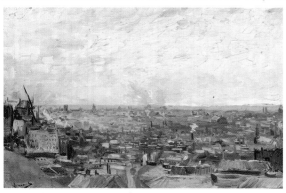

The boulevards de Clichy or de Rochechouart, the windmills on the hill of Montmartre amid gardens and vineyards, and the roofs of Paris were among Vincent's favorite subjects.

Theo welcomed his brother into his small apartment at the foot of the hill of Montmartre, on the Rue Laval (since renamed the Rue Victor-Massé). Vincent had not been back to Paris at all since Boussod had demanded his resignation ten years earlier. He had not seen a single picture by any of the painters who in 1874 were mockingly referred to as the Impressionists. Boussod and Valadon, the owners of the gallery of which Theo was the manager, would only tolerate showing the Impressionists on the mezzanine floor, and there Vincent's brother had hung a number of their paintings. Camille Pissarro was the first Impressionist whose paintings Theo had bought two years earlier; he also exhibited works by Honoré Daumier there.

In the first weeks of his stay in Paris Vincent discovered the works of the Impressionists

"In Antwerp I did not even know what the Impressionists were; now I have seen them and, though *not* being one of the club yet, I have much admired certain Impressionists' pictures." La Nouvelle Athènes, on the Place Pigalle, where they met, was a stone's throw from the Rue Laval, as was the paint shop of Julien Tanguy, called Père (Father) Tanguy by his friends, in the Rue Clauzel. Tanguy sold paintings from time to time for a few francs. He declared that a man who lived on more than 50 centimes a day was a rogue. Vincent, who seldom spent more, was welcomed by him with open

Self-Portrait, Paris, first half of 1886 or summer 1887.

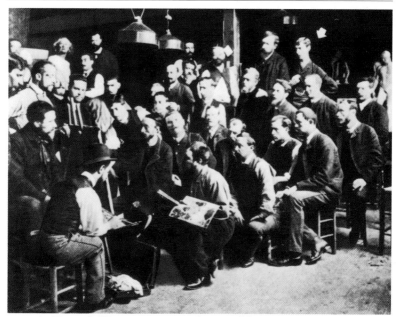

arms. At Tanguy's Vincent encountered some of the artists who worked in Cormon's studio: Emile Bernard, Louis Anquetin, John Russell, and Henri de Toulouse-Lautrec. He joined them in April.

Cormon had already won medals at the Salon, his first being in 1870, when he had exhibited his *Noces des Nibelungen.* According to one critic Cormon's painting was "like softened, weakened, faded Delacroix, made palatable for the young ladies"; in the eyes of Toulouse-Lautrec, his student from 1883 to 1886, Cormon had a "powerful, austere, and original talent." Students crowded into the famous studio. Every morning Vincent, who was unable to work in the apartment on the Rue Laval, went there to draw from live models. Cormon allowed him to come back in the afternoon to work there by himself with plaster casts of ancient sculptures. One day Emile Bernard·found him there rubbing holes in his sheet of paper "from the force of pressing it with an eraser." But Vincent did not find what he was looking for at Cormon's studio; he left after only four months.

Behind the canvas on which Cormon himself is working is Henri de Toulouse-Lautrec, sitting on a stool and wearing a bowler hat; Emile Bernard stands behind the assembled students at the right.

One painter among many, Vincent acted as a model for some of his comrades. John Russell painted his portrait, and Lucien Pissarro, the son of Camille, drew him beside the critic Félix Fénéon. Toulouse-Lautrec did a pastel of him. Vincent also became his own model. His new life was one of endless conversations, passions, and glasses of absinthe.

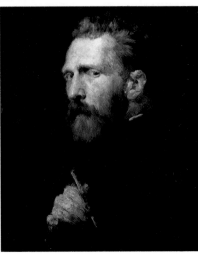

In the apartment to which he and Theo had moved, at 54 Rue Lepic, Vincent used one room as his studio: "I feel more like myself." Color found its way into his paintings which included still lifes of flowers and landscapes: "I have made a series of color studies in painting, simply flowers, red poppies, blue corn flowers and myosotis, white and rose roses, yellow chrysanthemums—seeking oppositions of blue with orange, red with green, yellow with violet,... trying to render intense color and not a gray harmony.... I also did a dozen landscapes, frankly green, frankly blue."

On 15 May 1886 the Eighth Impressionist Exhibition, organized by Eugène Manet, brother of the painter Edouard, and painter Berthe Morisot, Eugène's wife, was opened above the famous restaurant La Maison Dorée, off the Rue Laffitte. Monet, Renoir, and Alfred Sisley were absent, but Edgar Degas exhibited a series of pastels of women washing, and Camille Pissarro managed, though not without some difficulty, to

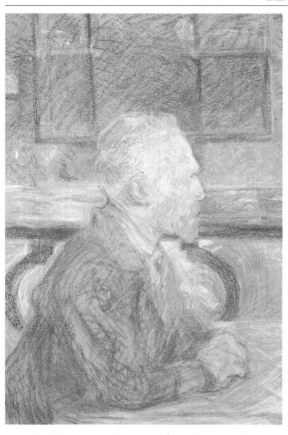

Vincent met Toulouse-Lautrec, who made this pastel portrait of him in 1887 (left), in Cormon's studio. They saw each other in the studio and in cafés.

Vincent sat in turn for several painters who were his friends: Lucien Pissarro drew him in discussion with the critic Félix Fénéon (far left, below), and John Russell painted his portrait in oil (far left, above).

In the spring of 1887, Vincent painted the view he saw from his studio in the Rue Lepic.

have Paul Signac and Georges Seurat admitted. The latter's painting *Sunday Afternoon on the Island of La Grande Jatte* caused a scandal. It was his technique, that of the "scientific Impressionists"—called Pointillism— that van Gogh made his own when he painted the view of Paris from the window of his room in the Rue Lepic or the gardens of Montmartre.

Gradually, Vincent took up the Impressionists' favorite themes himself

He often accompanied Emile Bernard on the latter's visits to his parents in Asnières: "While I was painting

landscapes in Asnières, I saw more colors there than ever before." As with Paul Gauguin, whom Vincent met upon Gauguin's return from his first stay in Pont-Aven, they exhibited their paintings together in a popular restaurant, A la Fourche, located at the corner of the Avenue de Clichy and the Avenue de Saint-Ouen. An altercation between Vincent and the manager brought the exhibition to an abrupt end, however, and they subsequently exhibited in a tavern on the Boulevard de Clichy, Le Tambourin. They were the painters of the "Petit Boulevard." The painters of the "Grand Boulevard" were Monet, Renoir, Degas, and Sisley, who were exhibited by the dealers Paul Durand-Ruel and Georges Petit.

This photograph captured a conversation between van Gogh, seen from behind, and Emile Bernard, in Asnières in 1884.

Agostina Segatori, who ran Le Tambourin, had acted as Degas' model. She allowed Vincent to cover the walls of the tavern with Japanese prints that he had bought at Samuel Bing's shop. When she brought their brief liaison to an end, Vincent had to force open the door of the restaurant to recover his pictures.

Upon his arrival in Paris, Vincent had written, "The air of France is clarifying my ideas and is doing me good, a lot of good, all the good in the world." A year and a half later, he could no longer stand it and declared, "And then I shall move away to somewhere in the Midi, to see less of those painters who disgust me as men." Fellow artist Armand Guillaumin remembered van Gogh's sudden fits of temper: "Vincent would get undressed, go down on his knees to help explain what he wanted to say, and nothing could calm him down." He threatened and insulted the wife of Père Tanguy, who found her husband's generosity toward him hard to accept. Theo concluded: "My home life is almost unbearable. No one

wants to come and see me anymore because it always ends in quarrels, and besides, he is so untidy that the room looks far from attractive. I wish he would go and live by himself. He sometimes mentions it, but if I were to tell him to go away, it would just give him a reason to stay."

Just as suddenly as he had arrived in Paris, Vincent left. After they visited Seurat's studio, Theo accompanied his brother to the station. At the end of a train journey lasting sixteen hours, on 20 February 1888, Vincent arrived in Arles, which he found covered in snow. The next day Vincent wrote to his brother: "It seems to me almost impossible to work in Paris unless one has some place of retreat where one can recuperate and get one's tranquility and poise back. Without that, one would get hopelessly stultified."

His first description of the landscape he was discovering confirmed Vincent's hope: "And the landscapes in the snow, with the summits white against a sky as luminous as the snow, were just like the winter landscapes that the Japanese have painted."

Asnières, where Vincent regularly visited Emile Bernard, was an important place for the Impressionists. Following in the footsteps of Monet, Renoir, Gustave Caillebotte, and Camille Pissarro, Vincent set up his easel there in the summer of 1887 and painted this *Road Along the Seine at Asnières*.

The masters of the popular Japanese school, led by Hokusai, fascinated Vincent, influencing his style and inspiring his painting *Japonaiserie: Oiran* (left, below).

Isolation in Arles and the quality of the light of Provence restored Vincent's peace of mind

Vincent's choice of Arles cannot be explained either by his reading of the works of Alphonse Daudet or Emile Zola, or by a brief meeting with Paul Cézanne at Père Tanguy's, or by his admiration of the landscapes of Adolphe Monticelli. He said in Paris that he could foresee "the possibility of making pictures in which there will be some youth and freshness, even though my own youth is one of the things I have lost." His ambition in Arles, where he took a room at the Carrel, a hotel and restaurant, was to paint pictures of that type.

As early as 22 February Vincent bought paints and canvas, which he found "either at a grocer's or at a bookshop," but neither source had all he needed. A landscape, the portrait of an old woman in Arles, and a pork-butcher's shop, evidently seen from the window of his room, were his first subjects. The presence in Arles of a red-haired Dutch painter astonished people. A few days after his arrival, a grocer and a magistrate, both amateur painters, paid him a visit which was the first and last visit he received. The local artists ignored him. People were alarmed by the solitary painter with the hoarse voice.

All day long Vincent walked through the surrounding countryside looking for subjects, for bridges or orchards in front of which he set up his easel as soon as the weather permitted it. He hardly spoke at all except to order his meals, and he spent hours writing very long letters to Theo, Gauguin, Emile Bernard, and Toulouse-Lautrec (who never replied): "Must I tell the truth and add that the Zouaves [a type of French soldier],

In the region around Arles Vincent rediscovered a subject he had always been fond of, that of rural work, as seen in *Wheat Field with Sheaves and Arles in the Background* (below and right). The light had changed and so had van Gogh's range of colors; his new paintings were all color and light. At left is a study for one of his self-portraits (the upper-left corner has been cut out of the original drawing), Paris, summer 1887.

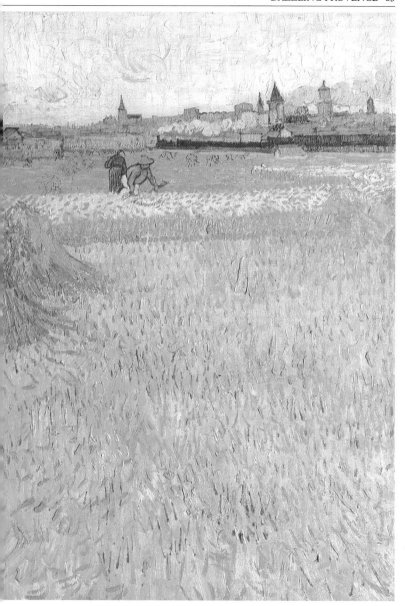

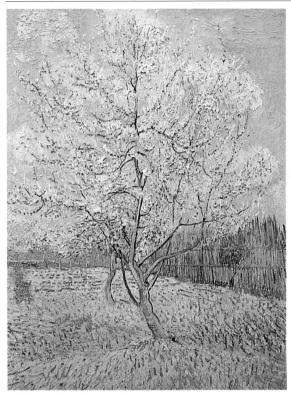

Pink Peach Trees, April–May 1888. In Provence, fruit trees blossom early. Fascinated by a nature that was new to him, and working at a frenetic pace, Vincent arrived in time to complete a whole series of paintings and drawings depicting, in an ebullient cascade of colors, almond, apricot, and peach trees. It was on a canvas similar to this one that he wrote, upon hearing of the death of his cousin, "Souvenir de Mauve" (Remembrance of Mauve).

the brothels, the adorable little Arlésiennes going to their first Communion, the priest in his surplice who looks like a dangerous rhinoceros, the people drinking absinthe, all seem to me creatures from another world."

Arles at first appeared to Vincent as a beautiful, bright, and cheerful place; but it was also the first town in which he experienced the intense bitterness and sadness of exile: "I would rather fool myself than feel alone. And I think I should feel depressed if I did not fool myself about everything." At the end of March, through Theo's efforts, three of Vincent's paintings were exhibited at the Salon des Indépendants in Paris: a still life, *Piles of French Novels and a Glass with a Rose (Romans Parisiens),* and two landscapes, *The Hill of Montmartre* and *The*

Moulin de la Galette. He specified, "In the future my name ought to be put in the catalogue as I sign it on the canvas, namely Vincent and not van Gogh, for the simple reason that they do not know how to pronounce the latter name here."

Vincent was thirty-five years old, and he was alone. Coming home one day after painting in an orchard, he found a letter from his sister Wilhelmina, informing him that Anton Mauve, the person who had first put a paintbrush into his hand, had died. He immediately wrote "Souvenir de Mauve" on the painting he had just completed, the best of the series of landscapes he had begun a few days earlier.

He was obsessed by thoughts of Holland. Yet, as he did not want to regret being in Arles, he told Theo, "I can assure you that the work I'm doing here is better than what I did in the Asnières country last spring." He explained to his sister: "At present the palette is distinctly colorful—sky blue, orange, pink, vermilion, bright yellow, bright green, bright burgundy, violet."

The intensity with which Vincent worked did not alter in any way the "melancholy thought that you yourself are not in real life"

He wrote, "It is more worthwhile to work in flesh and blood itself than in paint or plaster," and, "Even this artistic life, which we know is not real life, appears to me to be so alive and vital that it would be a form of ingratitude not to be content with it."

Vincent's need to paint triumphed over everything, even over the mistral wind. One of the orchard paintings, destined for Theo, who had just turned thirty-one, was "a frenzy of impastos of the faintest yellow and lilac on the original white mass." Such paintings proved to him that "nature here is precisely what one needs in order to make color." He could not paint for a number of days because of stomach pains, which he believed were

Vincent drew all that he discovered, including insects such as these *Three Cicadas*, Arles, summer 1888.

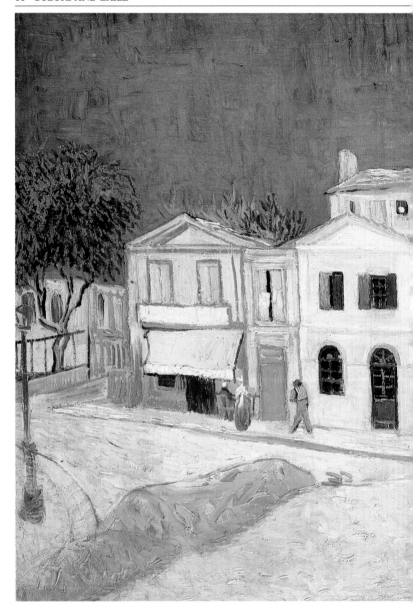

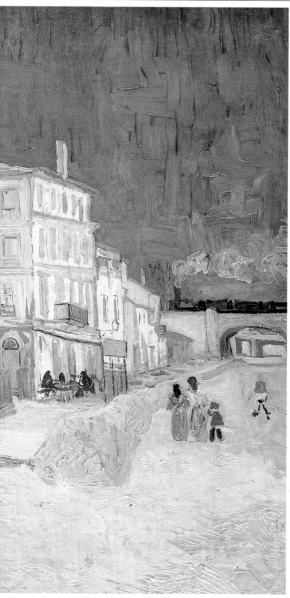

Vincent's House in Arles, September 1888. This house was for van Gogh more than just a place in which to work; it embodied his ambition to be able, finally, to create a studio where artists could work together and invent the painting of the future together. Van Gogh lived there for less than six months, from 18 September 1888 to 7 February 1889.

"Well, today I've taken the right wing of this complex, which contains four rooms, or rather two with two cabinets. It is painted yellow outside, whitewashed inside, on the sunny side. I have taken it for 15 francs a month. Now my idea would be to furnish one room, the one on the first floor, so as to be able to sleep there.... I hope I have landed on my feet this time, you know— yellow outside, white inside, with all the sun, so that I shall see my canvases in a bright interior."

To Theo
1 May 1888

caused by the cheap wine he had drunk too much of in Paris, and by toothache.

One and a half months after his arrival, he was certain that Arles was where he had to live from now on. In spite of the fact that Arles was a dirty town, life there seemed to him to be less contrary to nature than life in Paris, and, "although the people are blankly ignorant of painting in general, they are much more artistic than in the North in their own persons and their manner of life." He had to get settled in, "and at the end of that year I should have a decent establishment and my own health to show for it."

On 1 May, convinced that he was being overcharged at the hotel under the pretext that with all his paintings he was taking up more room than the other guests, Vincent rented a house at number 2 Place Lamartine. "It is painted yellow outside, whitewashed inside, on the sunny side. I have taken it for 15 francs a month." To get this house ready, he needed a bed, but the furniture salesman would neither rent him one nor accept payment on credit, which meant that he had to wait for his allowance from Theo to arrive. Vincent was convinced that "the Impressionist pictures will go up," that "the capital we have put out will have returned to our pockets again, if not in cash then in the value of the stock."

Even though he wanted to change, Vincent modestly doubted whether he could become the painter of the future, who would have to be "a colorist such as has never existed.... But this painter who is to come—I can't imagine him living in little cafés, working away with a lot of false teeth, and going to the Zouaves' brothels as I do."

Vincent, who claimed that he was nothing more than a "link in the chain of artists," could not remain by himself in the yellow house that he was getting ready. "But if we are preparing the richer lives for the painters who will follow in our footsteps, it will be something." He added, "The studio will also be available for friends."

Gauguin's Chair (left), painted by Vincent in December 1888, was a kind of portrait of Gauguin's absence, of Vincent's regret, and of the failure of a hope he had cherished.

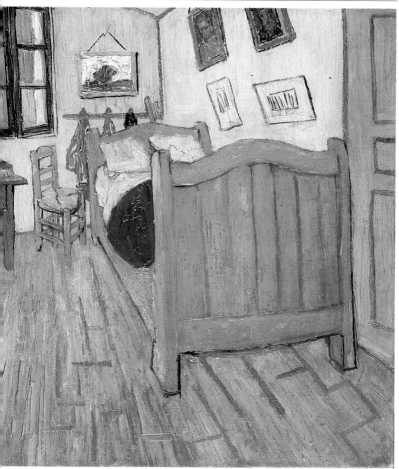

After furnishing the yellow house with a table and two chairs, he had just enough money left over to make some broth and some coffee. The 12 francs the judge ordered the hotel keeper Carrel to refund him allowed him to survive, yet again, until Theo's money order arrived. Vincent painted new landscapes—he went often to the abbey of Montmajeur—and new still lifes, and he sent more drawings to Theo. Still without a bed, he slept in the yellow house, which was above the Café de la Gare,

Vincent's Bedroom, October 1888. This painting was copied twice by Vincent when he was in the hospital; it became an icon of fullness and well-being, which he subsequently lost.

run by Joseph Ginoux and his wife, Marie, and took his meals at another café. His health improved.

When Theo wrote to him about Gauguin, who was ill, in debt, and utterly depressed, Vincent invited Gauguin to join him in Arles

He wrote to Gauguin himself, who was living at Pont-Aven. Vincent was spending five days drawing in Saintes-Maries-de-la-Mer while the yellow house was being completely repainted. He wanted "to achieve a more willful and more exaggerated form of drawing." His painting style also was evolving; he felt the need to work in larger formats and he wrote of one of the landscapes he was finishing that "it has more style."

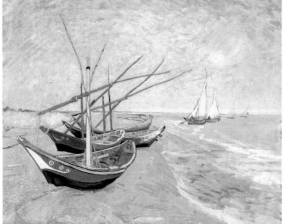

In five years Vincent's style had changed completely: At Scheveningen he had sought contour without color; now, at Saintes-Maries-de-la-Mer, it was color that gave contour to paintings such as *Fishing Boats on the Beach,* June 1888. The drawing above is from a letter of the same year.

Vincent thus began waiting for Gauguin's response, convinced that together they could take "a step forward." This step had to be taken in Provence because "the whole future of new art is in the Midi," because the air was transparent there (he remembered, though, that Cézanne often evoked its "harsh side"). He was ready to achieve his ambition as a painter: "I think that I shall at

On the pages of the letters he sent Theo, Vincent sketched the paintings he was working on, notably this *Street in Saintes-Maries,* 1888. To help himself to see them more clearly, he made note on the drawing of the colors used in the painting.

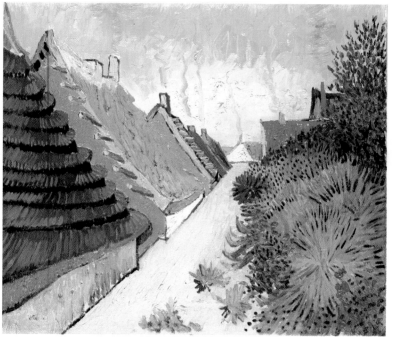

once indulge the fervent desire I have to paint the figure; I always seem to be getting around that, as if it weren't important, but in fact that is precisely where my goal lies." However, neither the beautiful Arlésiennes with their multicolored clothes, nor the girls of Saintes-Maries, "slim, straightforward, slightly sad and mystical," who reminded him of women painted by the pre-Renaissance Italian artists Cimabue and Giotto, would pose for him. The only people who agreed to pose were a second lieutenant from the Zouaves, to whom Vincent was giving drawing lessons and whom he was teaching how to use the perspective frame, and a young girl he had met in the street. He did not, however, stop doing landscapes. One thing that he was sure of comforted and reassured him: "Painters…dead and buried speak to the next generation or to several succeeding generations through their work." Yet it was by no means clear that Vincent considered himself to be one of those painters.

In late June, Vincent was overjoyed to learn that Gauguin had agreed to join him in Arles

Vincent was afraid of not being able to cope alone in the state he found himself after several working sessions in which he had had to repaint a canvas completely. At such times, extreme fatigue left him "hopelessly absentminded and incapable of heaps of ordinary things." The area around Arles, the Crau, and the Camargue were subjects that filled him with joy, yet he confided to Theo: "Is it the effect of this Ruisdael-like country? I keep thinking of Holland, and across the twofold remoteness of distance and time gone by these memories have a kind of heartbreak in them." Gauguin had still not arrived. The long letters Vincent wrote to Emile Bernard, whom he also urged to come down to Arles, developed into a kind of conversation that dealt exclusively with painting and painters. He constantly cited Rembrandt, Hals, Delacroix, Millet, and Daumier: "It may well be that those great geniuses were just crazy and that to have unlimited faith in them and admiration for them one must also be crazy."

Café Terrace at Night, September 1888. Vincent wanted to invent the light of his paintings, making use of all light sources, that of the stars as well as that of the lamps.

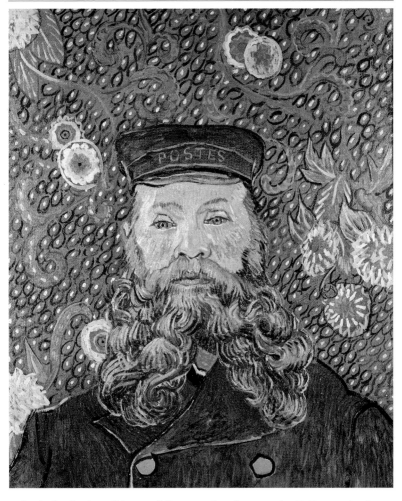

At the beginning of August, Vincent painted a portrait of Joseph Roulin, the postman who, staunch republican that he was, reminded him of Père Tanguy. A few weeks later Vincent did a portrait of a gardener named Patience Escalier. Ever since *The Potato Eaters,* he had not painted a single portrait of the peasants whose peer he considered himself to be. He "labored" over his canvases. He

Vincent painted *Joseph Roulin* six times in January and February 1889. The postman was Vincent's only friend in Arles.

considered it necessary to tell Theo that "the colors of this portrait are less dark than in *The Potato Eaters* of Nuenen." He painted several portraits of every sitter. Through this never-ending work, Vincent found that he was gradually losing all that he had learned in Paris from the Impressionists: "Instead of trying to depict exactly what is before my eyes, I am using color more arbitrarily to express myself forcefully."

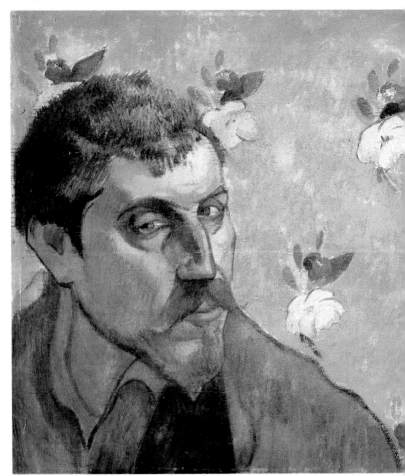

To Emile Bernard he wrote that he wanted to "do figures, figures, and more figures." In one of the few episodes in his long, difficult, disturbing, and despairing correspondence in which he was exultant, Vincent exclaimed, "Ah! my dear comrades, let us crazy ones take delight in our eyesight in spite of everything, yes, let's!"

Vincent was waiting for a companion and a master, but Gauguin did not know how to react to the weary Vincent's emotions

Gauguin had accepted the conditions offered by Theo, to pay for the hospitality he would be given in Arles with paintings. When he finally arrived on 28 October 1888, he did not come to a house decorated solely with portraits. Vincent had bought two beds—one made of walnut, the other of white wood—two mattresses, twelve chairs, and a mirror. He gave the house "a Daumier-like character." His own room, which appeared in several of his paintings, resembled a monastic cell. The room he had reserved for Gauguin was by contrast decorated with pictures of sunflowers and was "like the boudoir of a really artistic woman."

Ginoux, the owner of the Café de la Gare, recognized Gauguin, who got off the train at dawn. A few weeks earlier Vincent had shown Ginoux the self-portrait Gauguin had sent him in exchange for Vincent's own. Gauguin had painted himself against a floral wallpaper on which hangs a sketch of Emile

In this self-portrait, Gauguin wanted to paint himself "as Jean Valjean [the hero of Victor Hugo's novel *Les Misérables*], with his inner nobility and gentleness."

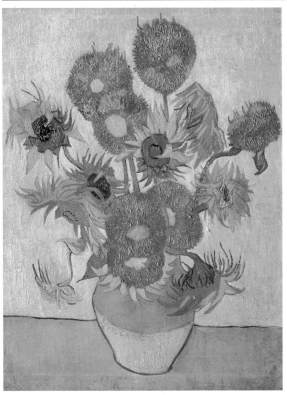

Sunflowers were Vincent's emblem. On 28 August 1888 he wrote to Theo that in the *Sunflowers* he had "painted with more simplicity" than ever before. For years nobody saw that simplicity, which he displayed in ten versions of *Sunflowers*. In 1987 one version was sold for close to $40 million.

Bernard's profile. The portrait of Vincent that Gauguin brought with him was of a "a simple monk adoring the eternal Buddha." Both paintings represented solitary and reprobate figures.

Gauguin's presence reassured the anxious Vincent. In the days following his arrival Gauguin organized their life. He decided that they should prepare their canvases and stretchers themselves; he bought a chest of drawers and household utensils and he did the cooking. Vincent observed that "with Gauguin, blood and sex triumph over ambition." Gauguin also determined the rate of their payments to the Zouave girls. Vincent noted, "He and I intend to make a tour of the brothels pretty often, so as to study them."

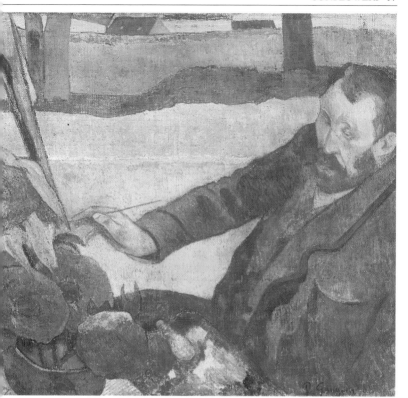

When faced with the same subjects, the two artists soon discovered correlations between their paintings. For example, Vincent's *The Red Vineyard* echoed Gauguin's *Human Miseries* or *Grape Harvests,* but Gauguin transformed the Arlésiennes picking grapes into Breton girls. That same painting prompted Vincent to paint *Promenade in Arles, Memory of the Garden at Etten,* to which Gauguin's *In the Garden of the Hospital in Arles* seems to correspond. Madame Ginoux is portrayed in the same position in both *The Arlésienne* by Vincent and *In the Café* by Gauguin. The two painters worked and talked together all the time. Gauguin painted Vincent painting sunflowers. Vincent copied a drawing by Gauguin.

Vincent Painting Sunflowers, by Gauguin, November 1888. When van Gogh saw this painting he said, "It's me all right, but it's me gone mad!"

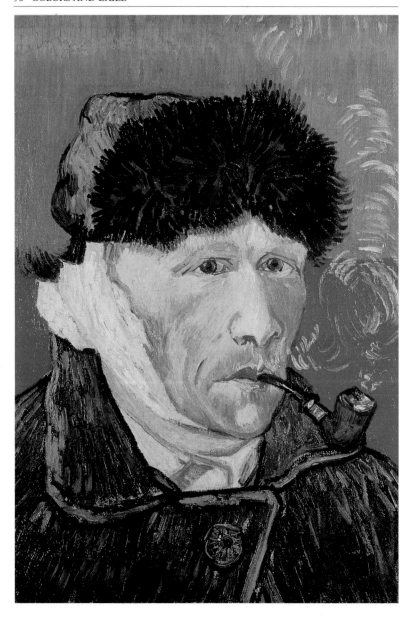

Barely a month after Gauguin's arrival, these conversations turned into confrontations. Their discussions about paintings were, according to Vincent, marked by "excessive electricity." A letter from Theo to Vincent confirms this fact: Gauguin, several of whose canvases had recently been sold, wanted to leave Arles. Vincent refused to believe that Gauguin wanted to leave, which would reduce him to an unbearable solitude.

On 23 December 1888, Gauguin went out alone after dinner for a walk through the town. Suddenly, he heard steps behind him. Just as he was turning around, Vincent rushed toward him brandishing an open razor, then stopped still and returned to the yellow house. Gauguin decided to spend the night at a hotel. The next day Gauguin returned to the Place Lamartine to find policemen and a crowd in front of the house; an inspector informed him that Vincent had died. In the downstairs rooms, Vincent had thrown blood-stained towels onto the flagstones, and the whitewashed walls on the staircase were spattered with blood. He was lying in bed, rolled up in the sheets, unconscious. The account that was given to Gauguin was undoubtedly the same as that which appeared in a short article in the *Forum républicain* on 30 December: He had gone to brothel number 1 at 11:30 P.M., asked for Rachel, and handed her his ear, saying, "Keep this object carefully." He had then disappeared. The police had found him at home the next day, lying in bed, apparently lifeless. Gauguin demanded that the chief of police summon a doctor. If Vincent asked for Gauguin, he was to be told that he had left for Paris. Vincent was admitted to the Hôtel-Dieu hospital in Arles. Gauguin, who was still in Arles, sent a telegram to Theo in Paris.

Self-Portrait with Bandaged Ear, January 1889, was painted barely a month after the self-mutilation had occurred. For Vincent, beginning to paint again was a way of standing up to his madness. Below: The 30 December 1888 issue of *Forum républicain,* in which the incident was reported.

24ᵐᵉ ANNÉE N° 53 CINQ CENTIMES LE NUMÉRO

LE

FORUM RÉPUBLI

JOURNAL DE L'ARRONDISSEMENT D'AR

Paraissant tous les Dimanches

Chronique locale

—

— Dimanche dernier, à 11 heures 1|2 du soir, le nommé Vincent Vaugogh, peintre, originaire de Hollande, s'est présenté à la maison de tolérance n° 1, a demandé la nommée Rachel, et lui a remis... son oreille en lui disant : « Gardez cet objet précieusement. » Puis il a disparu. Informée de ce fait qui ne pouvait être que celui d'un pauvre aliéné, la police s'est rendue le lendemain matin chez cet individu qu'elle a trouvé couché dans son lit, ne donnant presque plus signe de vie.

Ce malheureux a été admis d'urgence à l'hospice.

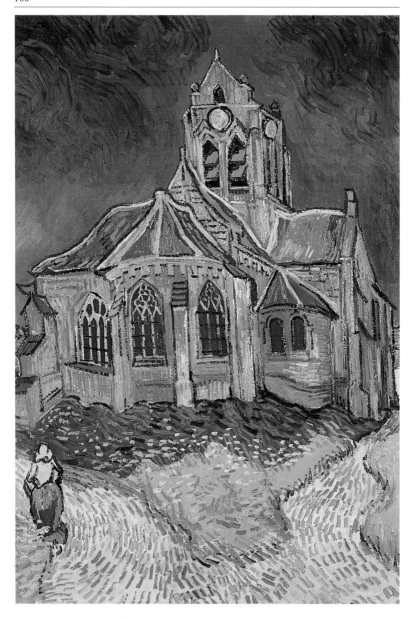

On 25 December 1888 the worst had almost happened. Vincent had fallen victim to a violent fit of delirium and was locked up in a cell at the Hôtel-Dieu in Arles. Theo arrived from Paris with all due haste and was horrified: "There is little hope. If it must be that he dies, so be it, but my heart breaks when I think of it."

CHAPTER V

THE ASYLUM AND DEATH

"The noise of Paris was making such a bad impression on me that I thought it wise, for the sake of my mind, to get away from it and to go out into the country."

To Gauguin
April 1890

The Church at Auvers-sur-Oise, 1890 (left). Sketch of a flowering branch (right).

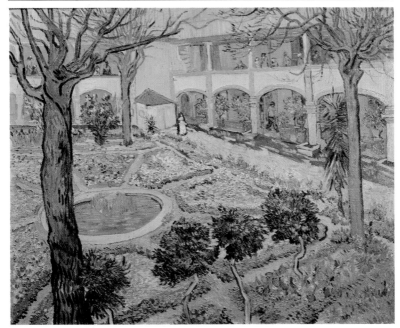

Theo asked the Reverend Frédéric Salles to help Vincent if he needed it. Theo could not stay longer than a day, and when he took the train back to Paris, Gauguin went with him. Dr. Rey from the hospital, the Reverend Salles, and Joseph Roulin all assured Theo that they would help his brother. On 27 December, after a visit from Madame Roulin, Vincent had another breakdown and had to be isolated. He could not speak and refused to take food. Theo and Dr. Rey considered transferring Vincent to a mental asylum in Aix-en-Provence. On 31 December the Reverend Salles reported: "I found him chatting calmly and he did not appear to be at all deranged. He is surprised and indignant about the fact that he is being kept locked up like this and that he is being totally deprived of his liberty, a fear and indignation that might be enough to bring on another crisis." On the back of a letter Vincent wrote to Theo on 2 January 1889, Dr. Rey added a few words: "I am happy to inform you that the overexcitement has been only temporary. I am firmly

The Courtyard of the Hospital at Arles, April 1889. The doctors at the Hôtel-Dieu in Arles allowed Vincent to paint. In the brief intervals when he was not "locked up," he used the courtyard as his subject.

convinced that he will be himself again in a few days." Roulin persuaded them to let Vincent visit the yellow house on 4 January. There was no sign of any crisis. Vincent wrote two letters on a single sheet of paper, to Theo on one side and to Gauguin on the other: "I wish you both prosperity in Paris."

On 7 January Vincent was able to check out of the hospital. He returned to the yellow house, eager to start painting again

Dr. Rey visited him that same day, and Vincent decided that he would paint Rey's portrait as soon as he felt

strong enough to do so. The letters he sent to his brother in Paris and to his mother and sister in Holland were meant to reassure them: "I hope that what I had was only a simple artist's craze and a high fever because of all the blood I lost when an artery was severed, but my appetite returned at once, my digestion is fine, and my blood is being renewed day by day so that my serenity of mind is also returning day by day."

The day after his discharge from the hospital, Vincent was penniless. After paying for the hospital, the cleaning woman, and the laundry, he was reduced to the "most rigorous fast." He reflected on the time Gauguin had spent with him, comparing him to one of the novelist Alphonse Daudet's characters, Tartarin, "the little Bonaparte tiger of Impressionism." He was just like the Little Corporal "who always left the armies in the lurch."

Vincent was overwhelmed by solitude. Theo had become engaged to a young woman, Johanna Berger, and could no longer concern himself exclusively with Vincent. A few days later Roulin told Vincent he was leaving for Marseilles. Vincent had done portraits of every member of his family, and Roulin was his only friend in Arles.

This photograph of Dr. Rey was taken in Arles while he was caring for van Gogh. As soon as he left the hospital, Vincent painted a portrait of the doctor; the latter's mother detested that painting so intensely that she used it to stop up a hole in the fence of her henhouse.

All Vincent wanted to do was to work: "Listen, let me quietly get on with my work; so what if it's the work of a madman! If it is, I can't do anything about it." He painted constantly. He produced new paintings of *Sunflowers* and of *Augustine Roulin with Her Baby,* for which she posed before the family's departure. Vincent did not see why anyone in the district should resent the fact that the man who had caused such a scandal had returned: "As everyone here is suffering either from fever, or hallucinations, or madness, we understand each other like members of the same family." He added, "But as for considering myself as completely sane, we must not do it."

On 7 February he was again admitted to the Hôtel-Dieu: For three days he had been afraid that somebody was trying to poison him. In his report to the police chief, Dr. Albert Delon confirmed that Vincent had been having hallucinations. On 13 February Dr. Rey telegraphed Theo: "Vincent much better, hope getting better, keeping him here. Do not worry now." Vincent took his meals and slept in the hospital. During the day he was allowed to paint in the yellow house.

A petition was being passed around the district: The Dutch painter had lost his senses and was a permanent danger to his neighbors

"The neighbors have raised a fuss over nothing," the Reverend Salles wrote to Theo. But the signatures on the petition were sufficient confirmation of the accusation in the eyes of the police chief. He concluded that Vincent could be a danger to the public and had to be locked up. He was placed in a cell and seals were put on the yellow house. "I miss working and am not made weary by it," Vincent wrote. He was resigned to what was happening, and depressed: "In today's society, we the artists are nothing more than a broken pitcher."

On 23 March, as he had promised Theo before leaving Paris, Signac went to see Vincent in the hospital; he accompanied Vincent to the yellow house and forced the door open. Their relaxed conversation about painting calmed Vincent. A little later that day, however, he

Old Man with His Head in His Hands (after the lithograph *At Eternity's Gate*), May 1890 (right). Eight years earlier, Vincent had drawn a seated old man who was weeping. One could interpret this portrayal of despair as a reflection of Vincent's own feelings of helplessness or simply of his habit of taking up again and again themes that obsessed him. Above: Advertisement for the asylum at Saint-Rémy.

attempted to swallow some turpentine, and Signac immediately led him back to the hospital. Dr. Rey "says that instead of eating enough at regular times, I kept myself going on coffee and alcohol. I admit all that, but all the same it is true that to attain the high yellow note I attained last summer, I really need to be pretty well keyed up." Thus, if the illness had a cause, it was related to the demands that painting made on him. "Unfortunately I have a handicraft that I do not know well enough to express myself as I should like."

The neighbors' anxious hostility made it impossible for Vincent to return to the yellow house, but he was allowed to bring his painting materials to the hospital. To Theo, who was leaving for Holland to marry Johanna, Vincent wrote: "If I had to stay in an asylum for good, I should resign myself to it and I think I could find subjects for painting there as well."

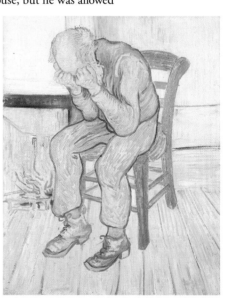

Vincent had his belongings moved out of the yellow house, and the Ginoux offered to let him store his few pieces of furniture at the Café de la Gare. He did not have the strength to live by himself. The Reverend Salles had told him of an institution in Saint-Rémy-de-Provence, and he did not want to procrastinate any longer: "You'll spare me any explanations, but I ask you [Theo] and Messrs. Salles and Rey to arrange things so that I can go there as a resident boarder at the end of this month or the beginning of May."

On 8 May Vincent was admitted to the asylum of Saint-Paul-de-Mausole, near Saint-Rémy-de-Provence

On 2 May he had sent two cases of paintings to Theo: "There are lots of daubs among them.... As a painter I shall never amount to anything important now, I am

absolutely sure of it." He was welcomed by Dr.
Peyron and the head nurse, Jean-François Poulet.
Two adjoining rooms had been prepared for him at
Theo's request. One would serve as his studio; the
other, which he moved into, had "greenish-gray
paper and two curtains of sea green with a design of
very pale roses, brightened by slight touches of blood
red." As soon as he moved in, Vincent began to
paint. The day after his arrival, he had already
sketched out two paintings: "some violet irises and a
lilac bush, two subjects taken from the garden."

His mental state did not worry him. He had now
"come to look upon madness as a disease like
any other." It did not matter to him that Dr.
Peyron felt he had been the victim of an
epileptic seizure. He was concerned only
with painting; his window looked out onto a
picture: "Through the iron-barred window I
see a square field of wheat in an enclosure, a
perspective like van Goyen." He was
indifferent to anything that did not have to
do with painting, including the shouts and
screams of the inmates, which he heard
continuously; the bland food; or the musty smell,
which reminded him of a "cockroach-infested
restaurant in Paris." He hoped that painting would
be able to stave off any further attacks, which he
feared because they brought on unbearable visual
and auditory hallucinations. But painting also
stimulated a regret that troubled him constantly: "I
am always filled with remorse, terribly so, when I
think of my work that is so little in harmony with
what I should have liked to do."

Only the regulated life of the asylum could enable Vincent to work. He could not bear to look at the people in the village

At Saint-Paul-de-Mausole, Vincent's only dialogue was
with his painting. He painted landscapes from his
window: "In this country there are many things that
often make you think of Ruisdael, but the figures of the
laborers are absent." Figures were absent from practically

The Asylum of Saint-
Paul-de-Mausole:
the vestibule (above);
Vincent's room (photo-
graph, center); the win-
dow of his room (below).

all the landscapes Vincent painted at Saint-Rémy. And when he did paint them, engraved reproductions of works by Millet, Delacroix, Rembrandt, or Gustave Doré acted as his models. Vincent copied his own paintings, including the portrait of Madame Ginoux as *The Arlésienne,* or his own room, over and over again.

On 7 July Vincent returned to Arles, accompanied by the director of Saint-Paul-de-Mausole, to collect eight of his paintings. He spent a day there but was unable to see the Reverend Salles or Dr. Rey. He did see the yellow house again, which was now derelict, and he visited the Ginoux. On the previous day Johanna had written to tell

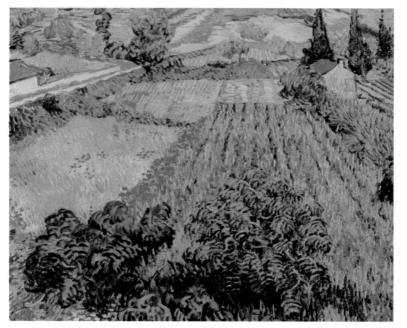

him that she and Theo were expecting a baby: "Next winter, toward February probably, we hope to have a baby, a pretty little boy—whom we are going to call Vincent, if you will kindly consent to be his godfather." Vincent replied with these broken sentences: "As for being godfather to a son of yours, when to begin with it

Fields with Poppies, April 1890. In this painting the touches of color themselves model the forms, conveying light and the impression of space.

may be a daughter, honestly, in the circumstances I would rather wait until I am away from here. Then Mother would certainly set her heart on its being called after our father. I for one would think that more logical in the circumstances."

Upon his return to Arles, Vincent had yet another severe breakdown. Theo was worried and sent a telegram to Dr. Peyron, whose reply confirmed his fears. Vincent was in despair: "I no longer see any possibility of having courage or hope but, after all, it wasn't yesterday that we discovered this job of ours was not a cheerful one." He begged Theo to persuade Dr. Peyron to allow him to go on painting. He had a relapse but then began to recover: "Work distracts me infinitely better than anything else, and if I could once really throw myself into it with all my energy, possibly that would be the best remedy."

Vincent repeated that he could only get better if he continued to work. At the beginning of September, he wrote to Theo that he was working on two self-portraits simultaneously. Once Theo could compare them to the ones he had done in Paris, he would see that Vincent was now better than he had been at that time.

At the Salon des Indépendants, two of Vincent's paintings—*Irises* and *The Starry Night*—were exhibited

The attacks that now tormented him were taking on "an absurd religious aspect." He wondered whether it wasn't the monastic architecture of the Hôtel-Dieu in Arles or the asylum in Saint-Rémy that was responsible for giving them that character. He missed the North; in the South of France, which he had once needed, he was now afraid that he would lose the ability to carry on working. Theo thought about bringing Vincent back to Paris or nearby, but Camille Pissarro, whom Theo had asked for advice and help, was having problems with his eyes and could not receive him at his home in Eragny. Vincent would have to wait. An immediate return would have been premature and dangerous.

At the beginning of October, Dr. Peyron told Theo that it was indeed too early for Vincent to leave the asylum. He would have to spend the winter there.

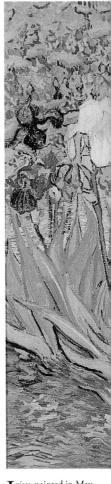

Irises, painted in May 1889, were one of the motifs Vincent discovered in the garden of the asylum at Saint-Rémy. Each of the pictures he painted there helped him to cope with his hallucinations.

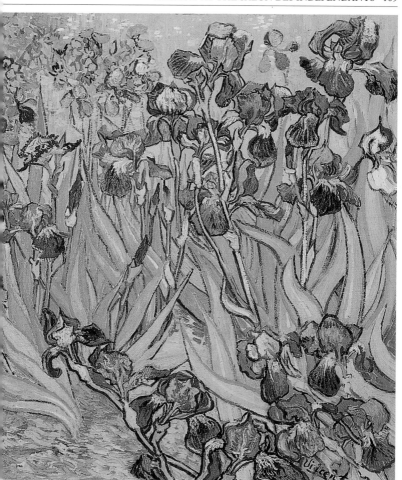

Vincent continued to send paintings to his brother, who
had had to rent a room at Père Tanguy's in which to store
them. Pissarro proposed a solution to Theo. He knew a
doctor, Dr. Paul Gachet, who had been a teacher of
artistic anatomy and who himself painted and made
engravings. Gachet was a friend of all the Impressionist
painters and all the writers who passed through his home
in Auvers-sur-Oise. Vincent would be welcomed into a

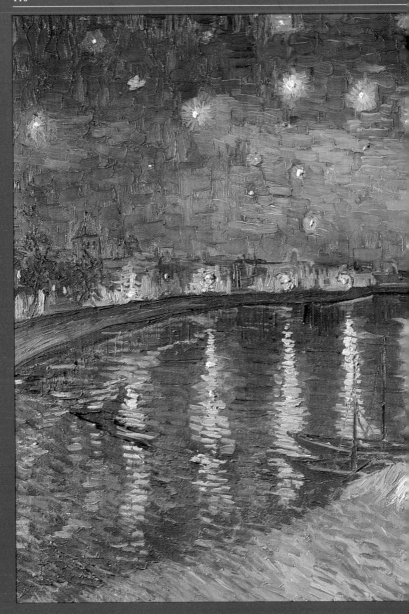

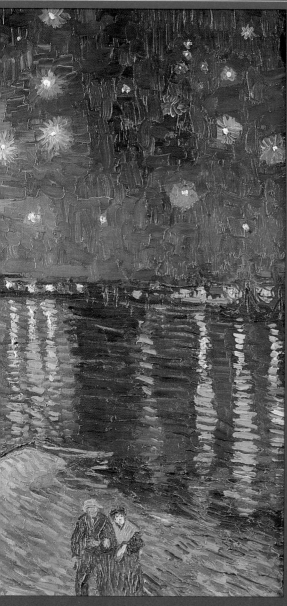

The Starry Night, painted in September 1889, was, for Vincent, who had discovered the power of light in Arles, a challenge to his art and an illustration of a dream. A year earlier he had written to his brother: "The sight of the stars always makes me dream, as simply as the black dots on a map representing towns and villages make me dream.... Just as we take the train to go to Tarascon or to Rouen, we take death to go to a star."

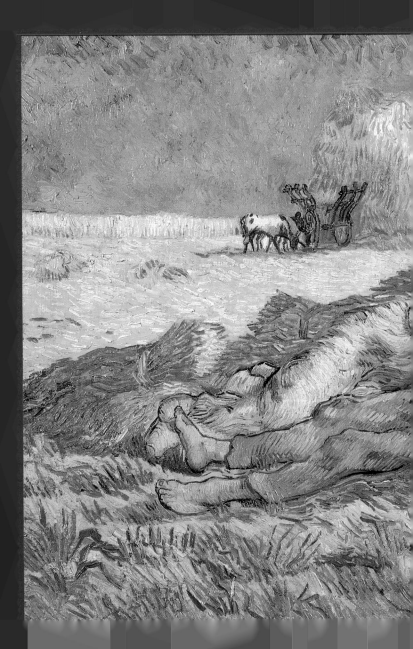

Noon: Rest (after Millet), January 1890. For the entire time that he was in the asylum of Saint-Paul, deprived of models and unable to bear the strain that days spent outside the asylum imposed on him, Vincent relied on engravings after the masters; in this way, he copied Rembrandt, Delacroix, Doré, and others. He based this work on Jacques-Adrien Lavieille's engraving of Millet's *The Four Hours of the Day*.

warm family environment. But weeks went by without any further attacks, and the plan seemed to have been abandoned. In November Octave Maus, secretary for *Les XX,* an artists' group in Brussels, invited Vincent to exhibit several paintings at the Eighth Salon, which he was organizing. Puvis de Chavannes, Cézanne, Jean Louis Forain, Toulouse-Lautrec, Renoir, and Sisley also were invited to send their works. Vincent accepted and sent six paintings on 30 November.

In Saint-Rémy Vincent worked "as hard and as unpretentiously as a peasant." In a letter to Emile Bernard, written in early December, he looked back on the year that was about to come to an end: "I have been slaving away on nature the whole year, hardly thinking of Impressionism or of this, that, and the other. And yet, once again I let myself go reaching for stars that are too big—a new failure—and I have had enough of it."

Suddenly, on 24 December, he had a violent, terrible attack that lasted a week. He tried to poison himself by sucking tubes of paint. As soon as it was over, he went back to work with the same certainty as before: "My work at least lets me retain a little of my clarity of mind and makes possible my getting rid of this someday." On 19 January he went back to Arles and visited the Ginoux. Two days after his return, a new attack incapacitated him for a week.

On 31 January Vincent's nephew, named Vincent Willem van Gogh, was born in Paris. Vincent also received Albert Aurier's article "The Isolated Ones," published in the January issue of the journal *Mercure de France:* "I was extremely surprised at the article on my pictures.... I needn't tell you that I hope to go on thinking that I do not paint like that, but I do see in it how I ought to paint." Vincent thanked Aurier in a long letter, writing that he would send him a study of some cypresses.

In the paintings Vincent made at the end of his stay in Provence, the subject of cypresses took over from the fruit trees that he had concentrated on in Arles.

"It is a dark stain in a sunny landscape, but it is one of the most interesting and difficult black notes to achieve that I can imagine. Well, you have to see them here against the blue color, or, to be more precise, in the blue color."

For the first and only time in his life, Vincent sold a painting. By that time he had painted more than seven hundred of them

The Red Vineyard was sold for 400 francs to Anna Boch. Vincent had painted two portraits of her brother, Eugène, in Arles. Dr. Peyron believed that Vincent was

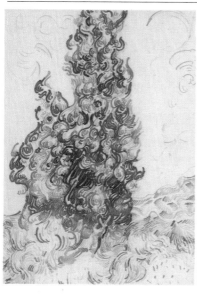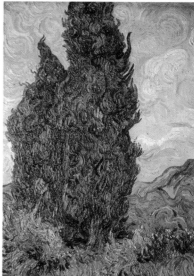

at last on the road to permanent recovery, but another attack confounded his hopes. When, at the end of April, he was able to write again, Vincent asked Theo to "please ask M. Aurier not to write any more articles on my painting; insist upon this, that to begin with he is mistaken about me, since I am too overwhelmed with grief to be able to face publicity. Making pictures distracts me, but if I hear them spoken of, it pains me more than he knows."

Vincent was disoriented and could not stand the asylum of Saint-Paul-de-Mausole any longer: "My surroundings here begin to weigh on me more than I can say—my word, I have been patient for more than a year—I need air; I feel overwhelmed with boredom and grief. I am at the end of my patience, my dear brother; I can't stand anymore—I must make a change, even a desperate one." He set himself the deadline of 15 May, to which Dr. Peyron did not object.

On 17 May 1890, Theo met Vincent on the platform at the Gare de Lyon in Paris and took him at once to 8, Cité Pigalle, where he and Johanna lived with their child.

> "The cypresses constantly occupy my thoughts. I should like to make something of them like the canvases of the sunflowers, because it astonishes me that they have proportions like Egyptian obelisks. And the green has a quality of such distinction."
>
> To Theo
> 25 June 1889

Johanna was surprised by the height, robustness, and calm of her brother-in-law. There were tears in both brothers' eyes as they bent over the young Vincent's cradle. Vincent did not leave the fourth-floor apartment at all that day. The next morning Theo took him to Père Tanguy's to see his storeroom, where there were paintings by Russell, Guillaumin, Gauguin, and Bernard, as well as his own. After a visit to the Salon of the Champ-de-Mars to see an exhibition of painters who had broken away from the old Salon, they did not have enough time left to see the Japanese exhibition at the Ecole des Beaux-Arts. Vincent did not want to stay in Paris any longer. Theo informed Dr. Gachet at once of his brother's imminent arrival.

Vincent got off the train at Auvers-sur-Oise with four paintings under his arm and a letter of introduction

The doctor, who gave Vincent the impression of being rather eccentric, took him to the café-tavern Saint-Aubin on the Rue Rémy, where board and lodging cost 6 francs a day. Vincent preferred to take a room at the house of the Ravoux family on the Place de la Mairie, where his board would cost only 3.50 francs per day. The Ravoux knew nothing of Vincent's past, and nothing in his speech or attitude hinted at his frailty. He thought Auvers was picturesque and painted it. Three days after his arrival, however, he doubted whether he could count on Gachet. He had gone to see the doctor unannounced, but Gachet was seeing patients in Paris.

On Sunday, 25 May, Vincent found Dr. Gachet at home. Gachet invited Vincent to paint at his house the following Tuesday and to show him his paintings. Vincent began to paint the doctor's portrait shortly afterward. Dr. Gachet invited Theo and his wife to spend a Sunday in Auvers. Vincent met them at the station, and they all had lunch in Gachet's garden, where Vincent introduced his young namesake to the chickens, rabbits, and cats. They went over to the Ravoux'

*c une casquette blanche Très blonde très claire les mains
rmation claire en frac bleu et un fond bleu cobalt
n une table rouge sur laquelle un livre jaune et
de digitale à fleurs pourpres. Cela ~~faib~~ ~~une~~ est dans
sentiment que le portrait de moi que j'ai pris lorsque
de pour ici. ~~Ibe et fans que je~~
t est absolument [analogue] pour ce portrait et veut
nje un de lui si je peux absolument comme cela
désire faire aussi. Il est maintenant aussi
, le dernier portrait D'arlésienne ~~et~~ dont tu en
nl lorsqu'il vient voir les études tout le temps
et il les admet en plein mais en plein tels qu'ils sont*

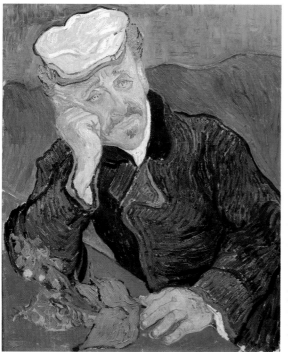

*D*octor Gachet at a Table with a Sprig of Foxglove in His Hand, Auvers-sur-Oise, June 1890. The doctor was an interesting man, but Vincent did not have absolute confidence in him. A friend of the Impressionists, Gachet invited several of them to stay with him in Auvers, including Camille Pissarro and Paul Cézanne, who did a painting of his house. The doctor was an engraver, and the engraving at lower left was printed on his own press. He signed his works with the pseudonym van Risle, the Flemish name for Lille, the city where he was born. Above left: The doctor as drawn by Vincent on a letter to Theo.

house to see Vincent's latest paintings. "A very restful impression," Vincent commented later.

The paintings done in Saint-Rémy arrived at Theo's home while Vincent continued to produce landscapes

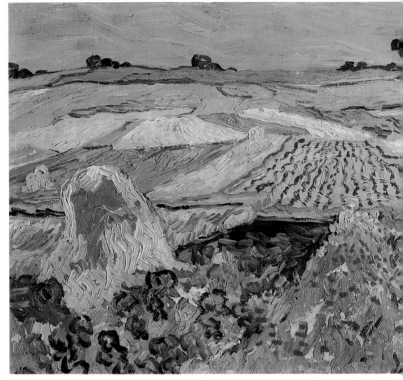

and portraits: of the Ravoux' daughter and of Dr.
Gachet's daughter, Marguerite. Vincent knew that his
furniture had left Arles and planned to rent a house in
Auvers that would cost only slightly more than his rent at
the Ravoux' house. However, his nephew, Vincent, fell ill
and Johanna was exhausted from many sleepless nights.
Theo grew anxious and wrote on 30 June, "Ought I to
live without a thought for the morrow, and when I work
all day long not earn enough to protect that good Jo from
worries over money matters, as those rats Boussod and
Valadon are treating me as though I had just entered their
business and are keeping me on a short allowance?" Theo
was hoping to leave the firm and to strike out on his own
as a dealer, working from home. On 6 July, when Vincent
arrived at the Cité Pigalle, Theo had still not made up

his mind, and Johanna was only just getting over her extreme exhaustion.

Albert Aurier, who had wished to meet the painter face to face ever since he had discovered Vincent's paintings at the Salon of Les XX, paid him a visit in Paris. Toulouse-Lautrec also joined them for lunch. Nervous and exhausted, Vincent could not wait for Guillaumin to turn up. As Vincent hurried to catch the train back to Auvers, Theo confided to his brother his increasing need to be very strict with money. He could not go on sending Vincent any on a regular basis, to which Vincent later responded, "I am very much afraid that I am stunned and I really have no idea on what conditions I have left, whether it's 150 francs per month, in three payments, as in the past."

Field with Trees and the Château of Auvers at Sunset, June 1890. The landscape has changed markedly over the past hundred years, but once one recognizes the spot where Vincent set down his easel, there is a clear correlation between the reality and his pictorial interpretation of it.

Wheat Field under Clouded Skies, July 1890. The sky of the Ile-de-France, always crossed by clouds whose shapes change constantly, formed a contrast with the clear sky of Provence and inspired Vincent's last paintings. The small white clouds that float in the light are closely related to those Vincent was so fond of in the paintings of Corot and Boudin, but Vincent strung them together in his own way, like links in a chain, emphasizing the force that propels them like sails propelling a ship.

Cottages with Thatched Roofs, Auvers-sur-Oise, 1890. On 21 May of that year, the date of his arrival in Auvers, Vincent wrote his brother that the place was "very beautiful; among other things [there are] a lot of old thatched roofs, which are getting rare"; he added that he hoped to do "some canvases of this…for really it is profoundly beautiful." Vincent walked all over the area around Auvers looking for subjects. Before the end of the second day spent on the banks of the Oise, he had already painted "one study of the old thatched roofs with a field of peas in flower in the foreground and some wheat, [with a] background of hills."

"Having returned here, I have found myself feeling much sadder. My life is being attacked at its very root, and the steps I am taking are unsteady"

Vincent went on painting. On 14 July he painted the

town hall, decorated with flags, with lanterns hanging from the trees in the square. He lived in solitude: "I think we must not count on Dr. Gachet *at all.*"

Theo traveled to Holland with his family. As soon as he returned, Theo sent 50 francs to Vincent, who thanked him and informed him that he had reduced an order of paints "to the bare minimum."

On 27 July 1890 the Ravoux became worried. Vincent, who was usually punctual, was not at the table in time for dinner, yet they had seen him come in. They found him in his second-floor garret, stretched out on his bed, lying in his own blood. He had shot himself.

Dr. Mazery and Dr. Gachet were summoned at once;

W*heat Field under Threatening Skies with Crows,* Auvers, July 1890. Many believe this to be the last canvas painted by van Gogh, although no reference to it can be found in any of his correspondence.

they decided not to remove the bullet, which had entered below the heart. Dr. Gachet wanted to send news to Theo, but Vincent refused to divulge his home address. The Ravoux and Gachet's son sat by Vincent's bedside all night long. Hirschig, another of the Ravoux' lodgers,

took the first train to Paris on Monday, 28 July, bearing a letter from Gachet to Theo. Theo arrived in Auvers at midday. He wrote to Jo full of hope, "His strong constitution deceived the doctors." Vincent was allowed to smoke his pipe. Vincent and Theo spoke a few last words to each other, in Dutch. At 1:30 A.M. on 29 July 1890, Vincent van Gogh was dead.

The news of Vincent's death was announced in the local newspaper (below). Barely a year later, Theo, the brother he had loved so much, died in Utrecht. In 1914 Theo's ashes were transferred to Auvers, where the two brothers' graves lie side by side.

L'ÉCHO PONTOISIEN

— **AUVERS-SUR-OISE.** — Dimanche 27 juillet, un nommé Van Gogh, âgé de 37 ans, sujet hollandais, artiste peintre, de passage à Auvers, s'est tiré un coup de revolver dans les champs et, n'étant que blessé, il est rentré à sa chambre où il est mort le surlendemain.

The parish priest of Auvers refused to give a funeral service to a man who had committed suicide. On 30 July Emile Bernard, Père Tanguy, Lucien Pissarro, A.-M. Lauzet, Andries Bonger, and Dr. Gachet accompanied Theo as he walked behind his brother's coffin in the searing heat. There were sunflowers among the yellow flowers that were thrown onto his grave. In Theo's pocket was an unfinished letter, found in Vincent's room: "Well, my own work, I am risking my life for it and my reason has half foundered because of it—that's all right—but you are not among the dealers in men as far as I know, and you can still choose your side, I think, acting with humanity, but what is it that you want?"

DOCUMENTS

Painting is a source of light and words pour out from it.
Engendered by painting, the words
of Vincent and of those who
loved him—the most secret as well as the most
ordinary words—shed light on that painting.

Letters

Vincent's first painting dates from 1881. He left behind 879 paintings at his death in 1890. In addition to this oeuvre, he left his immensely important correspondence, almost all of which has been preserved. From August 1872 until his death, Vincent wrote more than eight hundred letters, in Dutch, English, and in French. Six hundred sixty-eight of these are addressed to Theo, his brother, confidant, companion, and double.

Portrait of Theo van Gogh by J. J. Isaäcson.

Dear Theo,

In reply to your two good letters, and as a result of Father's visit, for which I had been longing for some time, I have a few things to tell you.

In the first place this. I hear from Father that without my knowing it you have been sending me money for a long time, in this way effectively helping me to get on. Accept my heartfelt thanks, I firmly believe that you will not regret it. In this way I am learning a handicraft, and though it certainly will not make me rich, I will at any rate earn my 100 francs a month, which is the least one needs to live on, as soon as I become a better draftsman and get some regular work.

What you told us about the painter Heyerdahl has greatly interested van Rappard as well as me.

As the former undoubtedly will write you about it himself, I speak about this question only in so far as it concerns me personally, more or less.

I find much truth in your remarks about the Dutch artists, that it is very doubtful if one could get from them any clear counsel on the difficulties of perspective, et cetera, with which I am struggling. At least I quite agree with you that someone like Heyerdahl would be far preferable (as he seems to be such a versatile man) to many others who do not possess the ability to explain their method and to provide the necessary guidance and teaching. You speak of Heyerdahl as one who takes great pains to seek "proportions for drawing"; that is just what I need. Many a good painter has not the slightest, or hardly any, idea of what proportions for drawing are, or beautiful lines, or characteristic composition, and thought and poetry. Yet these are important

questions, which Feyen-Perrin, and Ulysse Butin, and Alphonse Legros—not to mention Breton and Millet and Israëls—take extremely seriously and never lose sight of.

Many a Dutch painter would understand nothing, absolutely nothing, of the beautiful work of Boughton, Millais, Pinwell, du Maurier, Herkomer, and Walker, to name only a few artists who are real masters as draftsmen, not to mention their talent in other directions.

I say many of them look with contempt on such work, as many do on the work of de Groux, even among the painters here in Belgium who ought to know better. This week I saw some things by de Groux that I did not know, namely, a picture, *Departure of the*

Before the Hearth. Drawing accompanying Vincent's letter to Theo of January 1881.

Conscript, and a full-length drawing, *The Drunkard*—two compositions that resemble Boughton so much that I was struck by the resemblance, as of two brothers who had never met and who were yet of one mind.

So you see, I quite agree with your opinion on Heyerdahl, and I shall be very happy if later on you could put me in touch with that man; further, I will not insist on carrying out my plan of going to Holland, at least not if I have the prospect of going to Paris later and can more or less count on it.

But in the meantime what must I do? What do you think would be best? I can continue to work with Rappard for a few weeks, but then he will probably leave here. My bedroom is too small, and the light is no good, and the people would object to my partly shutting out the light from the window; I am not even allowed to put my etchings or my drawings up on the wall. So when Rappard leaves in May, I shall have to move; I should like to work awhile in the country—at Heyst, Calmphout, Etten, Scheveningen, Katwijk, anyplace, even nearer here, as Schaerbeek, Haeren, Groenendael. But preferably a place where there is a chance of coming into contact with other painters, and if possible of living and working together, because it is cheaper and better....

Yours sincerely, Vincent
Brussels, 2 April 1881

Dear brother,

I must just tell you about a trip to Zweeloo, the village where Liebermann stayed a long while, and where he made studies for his picture at the last Salon, the one with the poor washerwomen; where ter Meulen and Jules Bakhuyzen

have also been a long time. Imagine a trip across the heath at three o'clock in the morning, in an open cart (I went with the landlord, who had to go to the market in Assen), along a road, or "diek" as they call it here, which had been banked up with mud instead of sand. It was even more curious than going by barge. At the first glimpse of dawn, when everywhere the cocks began to crow near the cottages scattered all over the heath and the few cottages we passed—surrounded by thin poplars whose yellow leaves one could hear drop to earth—an old stumpy tower in a churchyard, with earthen wall and beech hedge—the level landscapes of heath or cornfields—it all, all, all became exactly like the most beautiful Corots. A quietness, a mystery, a peace, as only he has painted it.

But when we arrived at Zweeloo at six o'clock in the morning, it was still quite dark; I saw the real Corots even earlier in the morning.

The entrance to the village was splendid: enormous mossy roofs of houses, stables, sheepfolds, barns.

The broad-fronted houses here stand between oak trees of a splendid bronze. In the moss are tones of gold green; in the ground, tones of reddish, or bluish, or yellowish dark lilac gray; in the green of the cornfields, tones of inexpressible purity; on the wet trunks, tones of black, contrasting with the golden rain of whirling…autumn leaves—hanging in loose tufts, as if they had been blown there, and with the sky glimmering through them—from the poplars, the birches, the lime and apple trees.

The sky smooth and clear, luminous, not white but a lilac that can hardly be deciphered, white shimmering with red, blue, and yellow in which everything is reflected, and which one feels everywhere above one, which is vaporous and merges into the thin mist below—harmonizing everything in a gamut of delicate gray. I didn't find a single painter in Zweeloo, however, and people said *none* ever came *in winter*.

I, on the contrary, hope to be there *just* this winter.

As there were no painters, I decided not to wait for my landlord's return, but to walk back, and to make some drawings on the way. So I began a sketch of that little apple orchard, of which Liebermann made his large picture. And then I walked back along the road we had driven over early in the morning.

For the moment the whole country around Zweeloo is entirely covered—as far as the eye can see—with young corn, the very, very tenderest green I know.

With a sky over it of a delicate lilac-white, which gives an effect—I don't think it can be painted, but which is for me the keynote that one must know in order to understand the keynotes of other effects.…

When one has walked through that country for hours and hours, one feels that there is really nothing but that infinite earth—that green mold of corn or heather, that infinite sky. Horses and men seem no larger than fleas. One is not aware of anything, be it ever so large in itself; one only knows that there is earth and sky. However, in one's quality of a little speck noticing other little specks—leaving the infinite apart—one finds every little speck to be a Millet.

I passed a little old church exactly, exactly *The Church at Gréville* in

Millet's little picture in the [Musée du] Luxembourg; instead of the little peasant with his spade in that picture, there was here a shepherd with a flock of sheep walking along the hedge. There was not a glimpse of the true sea in the background, but only of the sea of young corn, the sea of furrows instead of the sea of waves.

The effect produced was the same. Then I saw plowers, very busy—a sandcart, a shepherd, road menders, dungcarts. In a little roadside inn I drew an old woman at the spinning wheel, a dark little silhouette out of a fairy tale—a dark little silhouette against a light window, through which one saw the clear sky, and a small path through the delicate green, and a few geese pecking at grass.

And then when twilight fell— imagine the quiet, the peace of it all!

Drawings added to a letter to Theo of January 1883 (above and p. 134).

Imagine then a little avenue of high poplars with autumn leaves, imagine a wide muddy road, all black mud, with an infinite heath to the right and an endless heath to the left, a few black triangular silhouettes of sod-built huts, through the little windows of which shines the red light of the little fire, with a few pools of dirty yellowish water that reflect the sky, and in which trunks lie rotting; imagine that swamp in the evening twilight, with a white sky over it, everywhere the contrast of black and white. And in that swamp a rough figure—the shepherd—a heap of oval masses, half wool, half mud, jostling each other, pushing each other—the flock. You see them coming—you find yourself in the midst of them—you turn around and follow them. Slowly and reluctantly they trudge along the muddy road. However, the farm looms in the distance—a few mossy roofs and piles of straw and peat between the poplars.

The sheepfold is again like the silhouette of a triangle—dark. The door is wide open like the entrance to a dark cave. Through the chinks of the boards behind it gleams the light of the sky. The whole caravan of masses of wool and mud disappear into that cave—the shepherd and a woman with a lantern shut the doors behind them.

That coming home of the flock in the twilight was the finale of the symphony I heard yesterday.

That day passed like a dream, all day I was so absorbed in that poignant music that I literally forgot even food and drink—I had taken a piece of brown bread and a cup of coffee in the little inn where I drew the spinning wheel. The day was over, and from dawn till twilight, or rather from one

night till the other, I had lost myself in that symphony.

I came home, and, sitting by the fire, I felt I was hungry, yes, very hungry. But now you see how it is here. One is feeling exactly as if one had been to an exhibition of the one hundred masterpieces, for instance; what does one bring home from such a day? Only a number of rough sketches. Yet there is another thing one brings home—a calm ardor for work.

Do write soon, today it is Friday, but your letter has not yet arrived; I am longing to get it. It also takes some time to get it changed, as I have to go to Hoogeveen for it and then return here. We do not know how things will go, otherwise I should say *now* the simplest thing would be perhaps to send the money *once* a month. At all events, write soon. With a handshake,

Yours sincerely, Vincent
1883

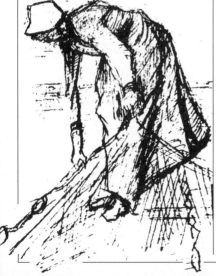

My dear Theo,

I wrote to you already, early this morning, then I went away to go on with a picture of a garden in the sunshine. Then I brought it back and went out again with a blank canvas, and that also is finished. And now I want to write you again.

Because I have never had such a chance, nature here being so *extraordinarily* beautiful. Everywhere and all over the vault of heaven is a marvelous blue, and the sun sheds a radiance of pure sulfur, and it is soft and as lovely as the combination of heavenly blues and yellows in a van der Meer of Delft [Jan Vermeer]. I cannot paint it as beautifully as that, but it absorbs me so much that I let myself go, never thinking of a single rule.

That makes three pictures of the gardens opposite the house. Then the two cafés, and then the sunflowers. Then the portrait of Bock and of myself. Then the red sun over the factory, and the men unloading sand, and the old mill. Not to mention the other studies, you see that I have got some work behind me. But my paints, my canvas, and my purse are all completely exhausted today. The last picture, done with the last tubes of paint on the last canvas, of a garden, green of course, is painted with pure green, nothing but Prussian blue and chrome yellow.

I am beginning to feel that I am quite a different creature from what I was when I came here. I have no doubts, no hesitation in attacking things, and this may increase. But what a country! I am in a public garden, quite close to the street of the kind girls, and Mourier, for instance, hardly ever went there, although we took a walk in

the gardens practically every day—but on the other side (there are three). But you realize, it is just this that gives a touch of Boccaccio to the place.

This side of the garden is also, for the same reason of chastity or morality, destitute of any flowering bushes such as oleanders. There are ordinary plane trees, pines in stiff clumps, a weeping tree, and the green grass. But it is all so intimate. Manet has gardens like this.

As long as you can manage to bear the burden of all this paint and canvas and all the money that I spend, keep on sending it. Because the stuff I am getting ready will be better than the last batch, and I think we shall make something on it instead of losing. If only I can manage to do a coherent whole. That is what I am trying to do.

But is it quite out of the question that Thomas would lend me 200 or 300 francs on my studies? That would let me make a profit of a thousand on it, for I cannot tell you often enough, I am ravished, ravished with what I see.

And it gives you ambitions for the autumn, enthusiasm that makes the time pass without your feeling it. Beware of the morning after the night before and the winter mistrals.

Today while I was working I thought a lot about Bernard. His letter is steeped in admiration for Gauguin's talent. He says that he thinks him so great an artist that he is almost afraid, and that he finds everything that he does himself poor in comparison with Gauguin. And you know that last winter Bernard was always picking quarrels with Gauguin. However this may be, and whatever happens, it is very comforting that these artists are our friends, and I dare say they will remain so, however the business turns out.

I am so happy in the house and in my work that I even dare to think that this happiness will not always be limited to one, but that you will have a share in it and good luck to go with it.

Some time ago I read an article on Dante, Petrarch, Boccaccio, Giotto, and Botticelli. Good Lord! It did make an impression on me reading the letters of those men.

And Petrarch lived quite near here in Avignon, and I am seeing the same cypresses and oleanders.

I have tried to put something of that into one of the pictures painted in a very thick impasto, citron yellow and lime green. Giotto moved me most— *always in pain,* and always full of kindness and enthusiasm, as though he were already living in a different world from ours.

And besides, Giotto is extraordinary. I understand him better than the poets Dante, Petrarch, and Boccaccio.

I always think that poetry is more *terrible* than painting, though painting is a dirtier and a much more worrying job. And then the painter never says anything, he holds his tongue, and I like that too.

My dear Theo, when you have seen the cypresses and the oleanders here, and the sun—and the day will come, you may be sure—then you will think even more often of the beautiful *Sweet Country* by Puvis de Chavannes, and many other pictures of his.

There is still a great deal of Greece all through the Tartarin and Daumier part of this queer country;...there is a Venus of Arles just as there is a Venus of Lesbos, and one still feels the youth of it in spite of all.

I haven't the slightest doubt that someday you too will know the South.

Perhaps you will go to see Claude Monet when he is at Antibes, or anyway you will find some opportunity.

When we have mistral down here, however, it is the exact opposite of a sweet country, for the mistral sets one on edge. But what compensations, what compensations when there is a day without wind—what intensity of color, what pure air, what vibrant serenity.

Tomorrow I am going to draw until the paints come. But I have deliberately arrived at the point where I will not draw a picture with charcoal. That's no use, you must attack drawing with the color itself in order to draw well.

Oh—the exhibition at the Revue Indépendante—good, but, once and for all, we are too good smokers to put the wrong end of the cigar into our mouths. We shall be forced to try to sell in order to do the things we sell over again, and better. That's because we are in a bad trade, but let's try something different from the fun of the fair that's the pest of the house.

This afternoon I had a select public—four or five hooligans and a dozen street Arabs, who were especially interested in seeing the paint come out of the tubes. Well, that same public—it meant fame, or rather I mean to laugh at ambition and fame, as I do at these street Arabs, and at the loafers on the banks of the Rhône and in the Rue du Pont d'Arles....

What is Seurat doing? I should not dare to show him the studies already sent, but the ones of the sunflowers, and the cabarets, and the gardens, I would like him to see those. I often think of his method, though I do not follow it at all; but he is an original colorist, and Signac too, though to a different degree, their stippling is a new

Facsimile of a letter to Theo with a drawing added, October 1888.

discovery, and at all events I like them very much. But I myself—I tell you frankly—am returning more to what I was looking for before I came to Paris. I do not know if anyone before me has talked about suggestive color, but Delacroix and Monticelli, without talking about it, did it.…

Ever yours, Vincent
1888

LETTER TO THEO

Now we come to the expenses caused you by Gauguin's telegram, which I have already expressly reproached him for sending.

Are the expenses thus mistakenly incurred less than 200 francs? Does Gauguin himself claim that it was a brilliant step to take? Look here, I won't say more about the absurdity of this measure, suppose that I was as wild as anything, then why wasn't our illustrious partner more collected?

But I shan't press the point.

I cannot commend you enough for paying Gauguin in such a way that he can only congratulate himself on any dealings he has had with us. Unfortunately there again is another expenditure perhaps greater than it should have been, yet I catch a glimpse of hope in it. Must he not, or at least should he not, begin to see that we were not exploiting him, but on the contrary were anxious to secure him a living, the possibility of work and…of decency?

If that does not attain the heights of the grandiose prospectuses for the association of artists that he proposed, and you know how he clings to it,… then why not consider him as not responsible for the trouble and waste that his blindness may have caused both you and me?

If at present this theory seems too bold to you, I do not insist on it, but we shall see.

He has had experience in what he calls "banking in Paris" and thinks himself clever at it. Perhaps you and I are not curious at all in this respect.

In any case this is not altogether in contradiction with some passages in our previous correspondence.

If Gauguin stayed in Paris for a while to examine himself thoroughly, or have himself examined by a specialist, I don't honestly know what the result might be.

On various occasions I have seen him do things that you and I would not let ourselves do, because we have consciences that feel differently about things. I have heard one or two things said of him, but having seen him at very, very close quarters, I think that he is carried away by his imagination, perhaps by pride, but…practically, [he is] irresponsible.

This conclusion does not imply that I advise you to pay very much attention to what he says on any occasion. But I see that you have acted with higher ideals in the matter of settling his bill, and so I think that we need not fear that he will involve us in the errors of the "Bank of Paris."

But as for him…Lord, let him do anything he wants, let him have his independence?? (whatever he means by that) and his opinions, and let him go his own way as soon as he thinks it better than we do.

I think it is rather strange that he claims a picture of sunflowers from me, offering me in exchange, I suppose, or as a gift, some studies he left here. I will send him back his studies, which will probably be useful to him, which they certainly wouldn't be to me.

But for the moment I am keeping my canvases here and I am definitely keeping my sunflowers in question.

He has two of them already, let that hold him.

And if he is not satisfied with the exchange he has made with me, he can take back his little Martinique canvas, and his self-portrait sent me from Brittany, at the same time giving me back both my portrait and the two sunflower canvases, which he has taken with him to Paris. So if he ever broaches this subject again, I've told you just how matters stand.

How can Gauguin pretend that he was afraid of upsetting me by his presence, when he can hardly deny that he knew I kept asking for him continually, and that he was told over and over again that I insisted on seeing him at once.

Just to tell him that we should keep it between him and me, without upsetting you. He would not listen.

It wearies me to go over all this and recapitulate such things over and over again.

In this letter I have tried to show you the differences between my net expenses, directly my own, and those for which I am less responsible.

I have been miserable because just at this moment you have had this expense, which did no one any good.

Whatever happens, I shall see my strength come back little by little if I can stick it out here. I do so dread a change or move just because of the fresh expense. I have been unable to get a breathing spell for a long time now. I am not giving up work, because there are moments when it is really getting on, and I believe that with patience the goal will at last be reached, that the pictures will pay back the money invested in making them....

Although this letter is already very long, since I have tried to analyze the month's expenses and complained a bit of the queer phenomenon of Gauguin's behavior in choosing not to speak to me again and clearing out, there are still some things that I must add in praise of him.

One good quality he has is the marvelous way he can apportion expenses from day to day.

While I am often absent-minded, preoccupied with aiming at *the goal,* he has far more money sense for each separate day than I have. But his weakness is that by a sudden freak or animal impulse he upsets everything he has arranged.

Now do you stay at your post once you have taken it, or do you desert it? I do not judge anyone in this, hoping not to be condemned myself in cases when my strength might fail me, but if Gauguin has so much real virtue, and such capacity for charity, how is he going to employ himself?

As for me, I have ceased to be able to follow his actions, and I give it up in silence, but with a questioning note all the same....

Ever yours, Vincent
17 January 1889

My dear Theo,

I am rather surprised that you have not written to me once during these days. However, as on the previous occasion when you went to Holland, it is mostly accidental.

I hope that everything has gone off well for you. Meanwhile I have been obliged to ask Tasset for 10 meters of canvas and some tubes.

And I still need:

12 zinc white	large tubes
1 emerald	"
2 cobalt	"
2 ultramarine	"
1 vermilion	"
4 malachite green	"
3 chrome I	"
1 chrome II	"
2 geranium lake	medium tubes

I have six studies of the spring, two of them big orchards. It is very urgent, because these effects are so short-lived.

So write me by return mail. I've taken an apartment consisting of two little rooms (at 6 to 8 francs per month, water included) belonging to Mr. Rey. It is certainly not expensive but nothing like as nice as the other studio.

But before I could manage the move or send you some canvases, I had to pay the other proprietor. And that is why I have been more or less surprised at your not sending anything. But no matter.

Hoping again that everything to do with your marriage has gone off to your liking, and wishing you and your wife much happiness from the bottom of my heart.

Ever yours, Vincent
1889

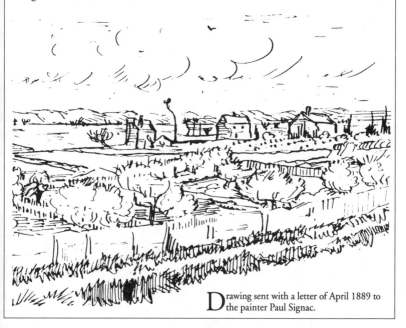

Drawing sent with a letter of April 1889 to the painter Paul Signac.

My dear friend Gauguin,

Thank you for having written to me again, old fellow, and rest assured that since my return I have thought of you every day. I stayed in Paris only three days, and the noise, et cetera, of Paris had such a bad effect on me that I thought it wise for my head's sake to fly to the country; but for that, I should soon have dropped in on you.

And it gives me enormous pleasure when you say the Arlésienne's portrait, which was based strictly on your drawing, is to your liking. I tried to be religiously faithful to your drawing, while nevertheless taking the liberty of interpreting through the medium of color the sober character and the style of the drawings in question. It is a synthesis of the Arlésiennes, if you like; as syntheses of the Arlésiennes are rare, take this as a work belonging to you and me as a summary of our months of work together. For my part I paid for doing it with another month of illness, but I also know that it is a canvas that will be understood by you, and by a very few others, as we would wish it to be understood. My friend Dr. Gachet here has taken to it altogether after two or three hesitations, and says, "How difficult it is to be simple." Very well—I want to underline the thing again by etching it, then let it be. Anyone who likes it can have it.

Have you also seen the olives? Meanwhile, I have a portrait of Dr. Gachet with the heartbroken expression of our time. *If you like,* something like what you said of your *Christ in the Garden of Olives,* not meant to be understood, but anyhow I follow you there, and my brother grasped that nuance absolutely.

I still have a cypress with a star from down there, a last attempt—a night sky with a moon without radiance, the slender crescent barely emerging from the opaque shadow cast by the earth—one star with an exaggerated brilliance, if you like, a soft brilliance of pink and green in the ultramarine sky, across which some clouds are hurrying. Below,

These graphite-pencil drawings appeared in the notebook Vincent carried with him in the last weeks of his life.

a road bordered with tall yellow canes, behind these the blue *Basses Alpes*, an old inn with yellow lighted windows, and a very tall cypress, very straight, very somber.

On the road, a yellow cart with a white horse in harness, and two late wayfarers. Very romantic, if you

like, but also very Provence, I think.

I shall probably etch this and also other landscapes and subjects, memories of Provence, then I shall look forward to giving you one, a whole summary, rather deliberate and studied. My brother says that Lauzet, who does the lithographs after Monticelli, liked the head of the Arlésienne in question.

But you will understand that having arrived in Paris a little confused, I have not yet seen your canvases. But I hope to return for a few days soon.

I'm very glad to learn from your letter that you are going back to Brittany with de Haan. It is very likely that—if you will allow me—I shall go there to join you for a month, to do a marine or two, but especially to see you again and make de Haan's acquaintance. Then we will try to do something purposeful and serious, such as our work would probably have become if we had been able to carry on down there.

Look, here's an idea that may suit you, I am trying to do some studies of wheat like this, but I cannot draw it— nothing but ears of wheat with green-blue stalks, long leaves like ribbons of green shot with pink, ears that are just turning yellow, edged with the pale pink of the dusty bloom—a pink bindweed at the bottom twisted round a stem.

After this I would like to paint some portraits against a very vivid yet tranquil background. There are the greens of a different quality, but of the same value, so as to form a whole of green tones, which by its vibration will make you think of the gentle rustle of the ears swaying in the breeze; it is not at all easy as a color scheme.

Unfinished letter
1890

Texts Concerning van Gogh

Van Gogh has been the subject of more books, articles, and theses than any other painter, in the same way that Napoleon and Joan of Arc have given rise to more books than any other historical figure. A total of 777 studies were published between 1890 and 1942. That is because, with his extraordinary blend of will, madness, and misery, Vincent remains an enigma.

Paul Gauguin, who was Vincent's model, master, and friend, and who lived with him for a time in Arles, writes about this relationship, which became so tormented that he finally fled from it.

I have heard about Vincent's death and I am glad you went to his funeral.

Sad though this death may be, I am not very grieved, for I knew how the poor fellow suffered in his struggles with madness. To die at this time is a great happiness for him, for it puts an end to his suffering, and if he returns in another life he will harvest the fruit of his fine conduct in this world (according to the law of Buddha). He took with him the consolation of not having been abandoned by his brother and of having been understood by a few artists....

To Emile Bernard
The Writings of a Savage

In every country I have to go through a period of incubation; each time I have to learn to recognize the various species of plants and trees, of all nature, so varied and so capricious, never willing to give away its secrets, to yield itself up.

So it was not until I had been there several weeks that I clearly perceived the harsh flavor of Arles and its environs. All the same, we worked hard, especially Vincent. Between two human beings, he and myself, the one like a volcano and the other boiling too, but inwardly, there was a battle in store, so to speak.

First of all, I was shocked. The paint box was barely big enough to contain all the tubes that had been squeezed but never recapped, and yet, in spite of the chaos and the mess, his canvases glowed; so

did his words. Daudet, de Goncourt, the Bible were burning up this Dutchman's brain. For him, the wharves, bridges, and boats of Arles, the entire Midi became Holland. He even forgot to write in Dutch and, as shown by the publication of his letters to his brother, he always wrote in French only, and wrote it admirably, too, with expressions like *tant que* [such that], *quant à* [with regard to] in abundance.

Despite my efforts to discern, in that chaotic brain, some logical reason for his critical views, I was unable to account for all the contradictions between his painting and his opinions. For instance, he felt boundless admiration for Meissonier and profoundly hated Ingres. Degas was his despair, and Cézanne was nothing but a humbug. The thought of Monticelli made him cry.

One thing that made him angry was having to acknowledge that I was very intelligent, for my forehead was too low, a sign of stupidity. And amid all this, a great tenderness, or rather, a Gospel-like altruism.

From the very first month I saw that our joint finances were becoming equally messy. What should we do? It was an awkward situation; the till was modestly filled by his brother, who worked in the Goupil firm; my share was paid in exchange for paintings. The matter had to be broached, at the risk of offending his excessive sensitivity. So very cautiously and with coaxing, quite out of character for me, I brought up the matter. I must admit that I succeeded much more easily than I had expected.

In a box, we put so much for nocturnal, hygienic outings, so much for tobacco, and so much for impromptu expenses, including rent. With it, a piece of paper and a pencil for writing down honestly what each of us took out of this cash box. In another box, the remainder of our resources, divided into four parts, for the cost of our food each week. We stopped going to our little restaurant, and I did the cooking on a little gas stove while Vincent did the marketing, without going very far from the house. One day, however, Vincent wanted to make a soup; I don't know how he mixed the ingredients—probably the way he mixed the colors in his paintings. Anyhow, we couldn't eat it.…

How long did we stay together? I couldn't begin to say, as I have completely forgotten. Although the catastrophe happened very quickly, and although I'd begun to work feverishly, that period seemed like a century to me.

Unbeknownst to the public, two men accomplished in that period a colossal amount of work, useful to both of them. Perhaps to others as well? Some things bear fruit.

When I arrived in Arles, Vincent was plunged into the Neo-Impressionist school, and he was floundering a good deal, which was painful to him; not that that school, like all schools, was bad, but because it did not correspond to his nature, which was so impatient and independent.

With all his combinations of yellow on purple, all his random work in complementary colors, all he achieved were soft, incomplete, monotonous harmonies: the clarion call was missing.

I undertook to enlighten him, which was easy enough, for I found rich and fertile soil. Like all independent natures that bear the stamp of personality,

Vincent was not the least bit afraid of what people would say, nor the least bit stubborn.

From that day on my friend van Gogh made astonishing progress; he seemed to glimpse all that he had in him, hence that whole series of sun after sun after sun, throbbing with sun.

It would be beside the point to go into technical details here. My aim is simply to inform you that van Gogh, without losing an iota of his originality, received most helpful instruction from me. And every day he was grateful to me for it. And that is what he meant when he wrote to Monsieur Aurier that he owes a great deal to Paul Gauguin.

When I arrived in Arles, Vincent was still feeling his way, whereas I, much older, was already a mature man. Yet along with the knowledge that I helped Vincent, I in turn owe something else to him: for that experience helped me to consolidate my own earlier ideas on painting; and even in the most trying periods, I can remember that some people are unhappier still....

Toward the end of my stay, Vincent became excessively abrupt and noisy, then silent. Several times, at night, Vincent got up and stood over my bed.

How is it that I happened to wake up just then?

Whatever the reason, all I had to do was to say to him very gravely: "What is the matter with you, Vincent?" Without a word, he would go back to bed and sleep like a log.

I decided to do a portrait of him in the act of painting the still life he liked so much, sunflowers. When the portrait was finished, he said to me: "That is me, all right, but me gone mad."

Paul Gauguin
The Writings of a Savage

One of the great achievements of the French writer Octave Mirbeau, who was active at the beginning of the twentieth century, was the campaign he led in favor of the artists of his time, who were completely misunderstood by the general public.

*S*elf-Portrait by Paul Gauguin, 1889.

What a strange personality, anxious yet strong...what a marvelous and fertile artistic temperament, this Vincent van Gogh, an exhibition of whose selected works, some of which are absolutely remarkable, may be seen today in M. Bernheim's galleries.... The name of van Gogh has always attracted me, as though to someone who is very different, very rare, and every day I regret more deeply not having known him. His life was passionate and fascinating, his death was painful and tragic. He died, if not a madman, then at least with an ailing mind. And yet, when reading the very interesting letters the *Mercure de France* published some time ago, there does not appear to be a

more well-balanced mind than his. His opinions were sound, free of any exaggeration. He was in no way a sectarian. He was fair to everyone, to Claude Monet as to Meissonier. In literature, he had rather timid views: he considered nothing as fine as the books of Guy de Maupassant.... Truly, there are few men who, in any order, can be as interesting as he can to those who are concerned with art and with human nature.

Madame Albert Besnard, that noble artist, possessed of so clear a genius, and so profound a critical mind, told me this one day: "We were in the Hague. We had spent the whole of that day visiting the museums and the private collections so that, despite our enthusiasm, we were saturated with painting, being completely tired out. Before returning to the hotel, the friend who was accompanying us wanted to drag us to a small exhibition that a relative of van Gogh's had organized, which consisted of about a hundred of his paintings.... He was so insistent that I did not want to offend him by refusing.... It was like taking a delightful rest.... I shall never forget the impression of freshness, of relaxation, of originality that I felt on entering that small hall.... These paintings were quite different from those we had enjoyed seeing all that day. In fact, they may well be the only ones that could stand this devastating comparison without being diminished by it.... And yet, in spite of the technique, which was sometimes heavy, sometimes awkward ...or at any rate, *very different,* despite these very dissimilar approaches to form, one could feel there a sort of distant kinship...a genius of the race was apparent in them...modified by

time...as well as by a very special personality...."

The power of originality...of passion ...the power of an art animated by a breath of passionate and sincere life!...

The mystics, the symbolists, the wash painters, the occultists, the painters of the soul, in fact...all those poor fools or those poor jokers who, as soon as they see in a picture a heavy fault of line or an embryonic form, or greenish flesh...and crucified genitals...proclaim the work a masterpiece, swoon with admiration and voluptuousness...they all, in turn, wanted to claim van Gogh as one of their own.... How amazingly pretentious...how incomprehensibly foolish!... Why van Gogh, rather than Monet or Cézanne?

The truth is that there is not a more healthy art...not an art that is more genuinely and more realistically painterly than the art of van Gogh.... Van Gogh has only one love, nature; only one guide: nature. He seeks nothing beyond it because he knows that there is nothing beyond it.... He even has an instinctive horror of philosophical, religious, or literary rebuses, of all of those vague intellectual movements that impotent artists find so appealing, because he also knows that all that is beautiful...*stupidly* beautiful, is intellectual!... Even when he paints the skies, their moving, changing, and multiple forms...lying women, tumbling flocks, fanciful fish... monsters, myths that disappear into the firmament to undergo new metamorphoses...even when he paints summer skies, with crazy stars and falling stars and whirling lights ...he remains within nature and only in nature and in painting.... His letters give us very valuable information in this regard.

They initiate us into his working method, which is almost exclusively what one could call scientific.... They tell us how, in composing a painting, the painter is preoccupied by nothing other than being a painter.... And he takes that preoccupation so far that when describing the landscape he is doing at that moment, or that he dreams of doing the next day, he does not say that there are fields, trees, houses or mountains...but yellows, blues, reds, greens, and the drama of their interrelationships....

In this way, he has reproduced, for our joy and our emotions, the fairy-tale aspects of nature, the enormous and magnificent joy, the miraculous feast of life....

Alas, he was not to paint for long!... A mortal anxiety—not at all metaphysical, but entirely professional—lay within him..... It gnawed at him and gradually destroyed him. Piece by piece, he gave it his whole being and it gradually ate him away.... He was never satisfied with his work.... He always dreamed of what lay beyond what he had achieved.... He dreamed of the impossible.... In wild fits of fury he raged against his hand, his timid and weak hand, which was unable to execute on the canvas all the perfection and genius that his brain conceived.... He died of that, one day!...

One must love Vincent van Gogh and always honor his memory, because he was truly a great and a pure artist....

Octave Mirbeau
"Vincent van Gogh"
The Journal, 17 March 1901

Le Père Tanguy

"Ah! poor Vincent! What misfortune. M. Mirbeau! What great misfortune!

Such a genius! And such a nice boy! Wait, I will show you more of his masterpieces! For there is no denying it, right? They are masterpieces!"

And brave Père Tanguy returned from the back of his shop with four or five canvases under his arms and two in each hand and set them up lovingly against the stretchers of the chairs placed more or less around us. As he sought the right natural light for the canvases, he continued to groan:

"Poor Vincent! Are they masterpieces, yes or no? And there are so many! And there are so many! And so beautiful, you see, that when I look at them I get a lump in my throat: I want to cry! We won't see him again, M. Mirbeau, we won't see him again! No, I can't get used to the idea! And M. Gauguin, who loved him so much! It's worse than if he had lost a son!"

He traced in the air with his finger a closed circle, as painters do:

"Look, that sky! That tree! Hasn't he got it? And all that, and all that! What color, what movement! Must a man like that die? I ask you, is it fair?... The last time he came here, he was sitting right where you are! Ah! how sad it was! I said to my wife: 'Vincent is too sad.... His eye is somewhere else, very far from here. I'm sure there is still something wrong there! He is not cured at all. He is not cured at all!' That poor Vincent! I bet you don't know his *Vase with Gladioli*. It's one of the last paintings that he did. A marvel! I have to show it to you! The flowers, you see, no one felt them like him. He felt everything, poor Vincent! He felt too much! It made him want the impossible! I'm going to find the *Vase with Gladioli* for you. M. Pissarro, who looked at it for a long time, and all those gentlemen said,

An invoice from September 1884 listing the paintings by Vincent left in storage at Père Tanguy's by Theo's widow.

'Vincent's flowers look like princesses!' Yes, yes, there's some of that! Wait for me just a minute. I'm coming back with the *Gladioli*."

I remember this scene at Père Tanguy's, a few days after the tragic, grievous death of van Gogh, whom the little man familiarly called Vincent, as his friends did.

Octave Mirbeau
"Le Père Tanguy"
On Artists

Antonin Artaud, who advocated a "central breaking down of the soul," a state of "mental animality," could not help but feel challenged by van Gogh, by the man as much as by his painting. His poetic study of van Gogh expresses a fervor that is almost frightening in its intensity.

These crows painted two days before [van Gogh's] death did not, any more than his other paintings, open the door for him to a certain posthumous glory, but they do open to painterly painting, or rather to unpainted nature, the secret door to a possible beyond, to a possible permanent reality, through the door opened by van Gogh to an enigmatic and sinister beyond.

It is not usual to see a man, with the shot that killed him already in his belly, crowding black crows onto a canvas, and under them a kind of meadow— perhaps livid, at any rate empty—in which the wine color of the earth is juxtaposed wildly with the dirty yellow of the wheat.

But no other painter besides van Gogh would have known how to find, as he did, in order to paint his crows, that truffle black, that "rich banquet" black—which is at the same time, as it were, excremental—of the wings of the crows surprised in the fading gleam of evening.

And what does the earth complain of down there under the wings of those *auspicious* crows, auspicious, no doubt, for van Gogh alone, and on the other hand, sumptuous augury of an evil that can no longer touch him?

For no one until then had turned the earth into that dirty linen twisted with wine and wet blood.

The sky in the painting is very low, bruised,
violet, like the lower edges of lightning.
The strange shadowy fringe of the void rising after the flash.
Van Gogh loosed his crows like the black microbes of his suicide's spleen a

few centimeters from the top *and as if from the bottom of the canvas,* following the black slash of that line where the beating of their rich plumage adds to the swirling of the terrestrial storm the heavy menace of a suffocation from above.

And yet the whole painting is rich.

Rich, sumptuous, and calm.

Worthy accompaniment to the death of the man who during his life set so many drunken suns whirling over so many unruly haystacks and who, desperate, with a bullet in his belly, had no choice but to flood a landscape with blood and wine, to drench the earth with a final emulsion, both dark and joyous, with a taste of bitter wine and spoiled vinegar.

And so the tone of the last canvas painted by van Gogh—he who, elsewhere, never went beyond painting— evokes the abrupt and barbarous tonal quality of the most moving, passionate, and impassioned Elizabethan drama.

This is what strikes me most of all in van Gogh, the most painterly of all

painters, and who, without going any further than what is called and is painting, without going beyond the tube, the brush, the framing of the *subject* and of the canvas to resort to anecdote, narrative, drama, picturesque action, or to the intrinsic beauty of subject or object, was able to imbue nature and objects with so much passion that not one of the fabulous tales of Edgar Allan Poe, Herman Melville, Nathaniel Hawthorne, Gérard de Nerval, Achim von Arnim, or Hoffman says more on a psychological and dramatic level than his unpretentious canvases,

his canvases, which are almost all, in fact, and as if deliberately, of modest dimensions.

Antonin Artaud
Van Gogh, the Man Suicided by Society

If van Gogh had not died at thirty-seven? I do not call in the Great Mourner to tell me with what supreme masterpieces painting would have been

enriched, for after *The Crows,* I cannot persuade myself that van Gogh would ever have painted again.

I think that he died at thirty-seven because he had, alas, reached the end of his dismal and revolting story of a man strangled by an evil spirit.

For it was not because of himself, because of the disease of his own madness, that van Gogh abandoned life.

It was under the pressure of the evil influence, two days before his death, of Dr. Gachet, a so-called psychiatrist, which was the direct, effective, and sufficient cause of his death.

When I read van Gogh's letters to his brother, I was left with the firm and sincere conviction that Dr. Gachet, "psychiatrist," actually detested van Gogh, painter, and that he detested him as a painter, but above all as a genius.

It is almost impossible to be a doctor and an honest man, but it is obscenely impossible to be a psychiatrist without at the same time bearing the stamp of the most incontestable madness: that of being unable to resist that old atavistic reflex of the mass of humanity, which makes any man of science who is absorbed by this mass a kind of natural and inborn enemy of all genius.

Medicine was born of evil, if it was not born of illness, and if it has, on the contrary, provoked and created illness out of nothing to justify its own existence; but psychiatry was born of the vulgar mob of creatures who wanted to preserve the evil at the source of illness and who have thus pulled out of their own inner nothingness a kind of Swiss guard to cut off at its root that impulse of rebellious vindication which is at the origin of genius.

There is in every lunatic a misunderstood genius whose idea, shining in his head, frightened people, and for whom delirium was the only solution to the strangulation that life had prepared for him.

Dr. Gachet did not tell van Gogh that he was there to straighten out his painting (as Dr. Gaston Ferdière, head physician of the asylum of Rodez, told me he was there to straighten out my poetry), but he sent him to paint from nature, to bury himself in a landscape to escape the pain of thinking.

Except that, as soon as van Gogh had turned his back, Dr. Gachet turned off the switch to his mind.

As if, without intending any harm but with one of those seemingly innocent disparaging wrinklings of the nose where the whole bourgeois unconscious of the earth has inscribed the old magic force of a thought one hundred times repressed.

In so doing, it was not only the evil of the problem that Dr. Gachet forbade him,

but the sulfurous insemination,

the horror of the nail turning in the gullet of the only passage,

with which van Gogh,

tetanized,

van Gogh, suspended over the chasm of breath,

painted.

For van Gogh was a terrible sensibility.

Antonin Artaud
Van Gogh, the Man Suicided by Society

Georges Bataille based his thinking on what, in 1943, he called "the inner experience." Bataille and Artaud both were interested in extreme experience and

both evoked, by excessive verbal means, the impression that the unfathomable work of Vincent van Gogh made upon them.

How can dominant figures appear with a persuasive force that reassures one? How do forms that appear in the chaotic realm of countless possibilities suddenly shine with a light that leaves no room for further doubt? To most people this phenomenon seems to be independent of the growth of the crowd. Moreover, no truth is calmly accepted any longer: the significance of a painting cannot in any way depend on the consent of another person, in the eyes of anyone who has at some time been absorbed in a prolonged contemplation of such a painting.

It is true that such a point of view is the negation of anything obvious that happens in front of paintings in an exhibition: every visitor seeks, above all, not what he likes but the reactions that others expect of him. But there is not much point in emphasizing the poverty to which anyone can fall victim, whether in looking at pictures or reading. Beyond these ridiculous limits imposed on life by current habit, even when this occurs in favor of an ill-considered fashion, such as the fashion that is developing around the paintings and the name of van Gogh, it is possible to open up a world which is no longer that of some individual who maliciously drives away the crowds, but our world, the world of a person who, with the arrival of spring, sheds his heavy, dusty winter coat.

If such a person allowed himself to be carried by the crowd, with even more innocence than disdain, he would not be able to look without terror at the tragic paintings that are so many painful traces of Vincent van Gogh's life. However, that person might then be able to feel the greatness represented not in Vincent himself (he is nothing; he is still stumbling constantly around beneath the weight of common troubles), but in what he wears in his nudity, the countless hopes of every human being who wants to live and, if it be necessary, to free the world of the power that does not resemble him; overwhelmed by this greatness that is still to come, the terror he feels would appear to him as laughable, just as Vincent's ear, brothel, and suicide would appear laughable. Did he not make of the human tragedy the sole object of his entire life, whether he was crying, laughing, loving or, above all, struggling?

He could not, indeed, help but be moved to laughter by the powerful magic that continues to take place before his eyes, undoubtedly the same magic that an entire crowd possessed by

Georges Bataille.

drink, repeated chants, and the beating of many drums would demand of a group of natives. For it was not only a bleeding ear that van Gogh cut from his own head, to carry it to that "House"— a troubling image, childish in a vulgar way, of the world that we make up for others—but much more than an ear. Van Gogh who, from as early as 1882 thought it would be better to be Prometheus than Jupiter, cut a Sun out of himself.

More than any other condition, human existence requires stability, the permanence of things, and an ambiguous attitude emerges in response to any large or violent expenditure of energy. These expenditures, whether they result from nature or from the individual himself, constitute the greatest possible threats. The feelings of admiration and ecstasy that they provoke thus inspire in us a concern to admire them from afar. The sun corresponds to this principle of cautious concern in the most appropriate way. It is nothing more than radiation, an enormous loss of heat and light, a flame, an explosion; but it is far from man, who can, from a distance, enjoy the calm fruits of this great cataclysm. The earth has the solid structure that can support stone houses and the steps of human beings (at least its surface has that structure; below it lies molten lava).

Bearing these points in mind, it must be said that after the night of December 1888, when his ear had met with an unknown fate in the house in which he left it (one can faintly imagine the laughter and the malaise that preceded some obscure decision about what to do with it), van Gogh began to give the sun a meaning it had not previously had. He did not include it in his paintings as part of a décor but used it as the sorcerer whose dance slowly excites the crowd and carries it off in his movement. It was at that moment that his entire art was fully transformed into a glow, explosion, or flame and that he was himself lost in an ecstasy before a hearth of shining, exploding, burning light. When this solar dance began, nature herself was suddenly stirred, the plants caught fire and the earth buckled like a stormy sea or burst open; nothing was left of the stability that forms the basis of things. Death appeared in all its clarity, as the sun appears through the blood in a living hand, between the bones that mark the shade. In the flowers that were opening out and fading and in the face whose haggard radiance depresses one, the "sunflower" van Gogh (anxiety? domination?) put an end to the power of immutable laws, the foundations of all that gives so many human faces their repugnant, wall-like look of closure.

But one should not be led by this original choice of the sun to make an absurd error; the paintings of van Gogh are nothing more than Prometheus' theft, a homage to the distant sovereign of the sky and the sun is not dominant in them because it has been captured. Far from recognizing the distant power of the celestial cataclysm, as if all that was needed was to better stretch out the monotonous earthly surfaces that are sheltered from all change, the Earth, like a girl suddenly captivated and perverted by the debaucheries of her father, becomes in her turn intoxicated with the cataclysm, the explosive loss, and with the radiance.

That is what explains the tremendous festive power of van Gogh's paintings. Did the painter not have, to a greater

extent than any other individual, the sense of the flowers that also represent on earth the intoxication, the happy perversion of the flowers that burst forth, shine and point their inflamed festival at the rays of the same sun that will wither them? There are in this profound birth so many troubling aspects that inspire laughter; how can one avoid seeing the appearance of a chain of events, which surely include the ear, the asylum, the sun, the most radiant of festivals, and death. Van Gogh cut off his ear with one stroke of a razor; he then carried it to a familiar brothel; madness incited him in the same way that a violent dance arouses a collective ecstasy; he painted his finest works; he remained locked up for a time in an asylum; and eighteen months after cutting off his ear, he killed himself.

If it all happened like this, what significance does art or criticism still have? Is it even possible to maintain that, given these conditions, art alone is responsible for the noise and shuffle of the crowds in the galleries of an exhibition. Vincent van Gogh does not belong to the history of art but to the bloody myth of our human existence. He is one of the rare individuals who, in a world spellbound by stability and sleep, suddenly arrived at the terrible "boiling point," without which that which aims to last becomes…dull and declines. Such a "boiling point" has meaning not only for the person who reaches it, but for all, even if all do not yet notice what it is that links the savage human destiny to the radiance, the explosion, the flame, and by these means alone, to power.

Georges Bataille
"Van Gogh Prometheus"

G.-Albert Aurier, poet and art critic, met Vincent van Gogh in 1889, in his brother's apartment, where he probably saw his paintings for the first time. Tremendously impressed, Aurier published "The Isolated Ones: Vincent van Gogh" six months later, in January 1890, in the first issue of the Mercure de France.

Beneath skies that sometimes dazzle like faceted sapphires or turquoises, that sometimes are molded of infernal, hot, noxious, and blinding sulfurs; beneath skies like streams of molten metals and crystals, which, at times, expose radiating, torrid solar disks; beneath the incessant and formidable streaming of

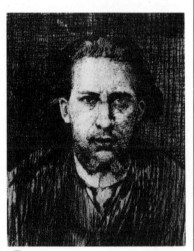

G.-Albert Aurier.

every conceivable effect of light, in heavy, flaming, burning atmospheres that seem to be exhaled from fantastic furnaces where gold and diamonds and singular gems are volatilized—there is the disquieting and disturbing display

of a strange nature, that is at once entirely realistic and yet almost supernatural, of an excessive nature where everything—beings and things, shadows and lights, forms and colors—rears and rises up with a raging will to howl its own essential song in the most intense and fiercely high-pitched timbre: Trees, twisted like giants in battle, proclaiming with the gestures of their gnarled menacing arms and with the tragic waving of their green manes their indomitable power, the pride of their musculature, their blood-hot sap, their eternal defiance of hurricane, lightning, and malevolent Nature; cypresses that expose their nightmarish, flamelike, black silhouettes; mountains that arch their backs like mammoths or rhinoceri; white and pink and golden orchards, like the idealizing dreams of virgins; squatting, passionately contorted houses, in a like manner to beings who exult, who suffer, who think; stones, terrains, bushes, grassy fields, gardens, and rivers that seem sculpted out of unknown minerals, polished, glimmering, iridescent, enchanted; flaming landscapes, like the effervescence of multicolored enamels in some alchemist's diabolical crucible; foliage that seems of ancient bronze, of new copper, of spun glass; flowerbeds that appear less like flowers than opulent jewelry fashioned from rubies, agates, onyx, emeralds, corundums, chrysoberyls, amethysts, and chalcedonies; it is the universal, mad, and blinding coruscation of things; it is matter and all of Nature frenetically contorted… raised to the heights of exacerbation; it is form, becoming nightmare; color, becoming flame, lava, and precious stone; light turning into conflagration; life, into burning fever.

Such…is the impression left upon the retina when it first views the strange, intense, and feverish work of Vincent van Gogh, that compatriot and not unworthy descendant of the old Dutch masters.

Oh! how far we are—are we not?—from the beautiful, great traditional art, so healthy and very well balanced, of the Dutch past. How far from the…de Hooghes, the van der Meers, the van der Heydens and from their charming canvases, a bit bourgeois, so patiently detailed, so phlegmatically overfinished, so scrupulously meticulous! How far from the handsome landscapes, so restrained, so well balanced, so time-lessly enveloped in soft tones, grays, and indistinct haze, those…van Ostades, Potters, van Goyens, Ruisdaels, Hobbemas!… How far from the deli-cate, always somewhat cloudy and somber colors of the northern countries.…

And yet, make no mistake, Vincent van Gogh has by no means transcended his heritage. He was subject to the effect of the ineluctable atavistic laws. He is good and duly Dutch, of the sublime lineage of Frans Hals.

And foremost, like all his illustrious compatriots, he is indeed a realist, a realist in the fullest sense of the term. *Ars est homo, additus naturae,* Chancellor Bacon said, and Monsieur Emile Zola defined naturalism as "nature seen through the temperament." Well, it is this "homo additus," this "through a temperament," or this molding of the objective unity into a subjective diversity that complicates the question and abolishes the possibility of any absolute criterion for gauging the degrees of the artist's sincerity. To

determine this, the critic is thus inevitably reduced to more or less hypothetical, but always questionable, conclusions. Nevertheless, in the case of Vincent van Gogh, in my opinion, despite the sometimes misleading strangeness of his works, it is difficult for an unprejudiced and knowledgeable viewer to deny or question the naive truthfulness of his art, the ingeniousness of his vision. Indeed, independent of this indefinable aroma of good faith and of the truly seen that all his paintings exude, the choice of subjects, the constant harmony between the most excessive color notes, the conscientious study of character, the continual search for the essential sign of each thing, a thousand significant details undeniably assert his profound and almost childlike sincerity, his great love for nature and for truth—his own personal truth.

Given this, we are thus able to infer legitimately from Vincent van Gogh's works themselves his temperament as a man, or rather, as an artist—an inference that I could, if I wished, corroborate with biographical facts. What characterizes his work as a whole is its excess…of strength, of nervousness, its violence of expression. In his categorical affirmation of the character of things, in his often daring simplification of forms, in his insolence in confronting the sun head-on, in the vehement passion of his drawing and color, even to the smallest details of his technique, a powerful figure is revealed…masculine, daring, very often brutal, and yet sometimes ingenuously delicate.…

Yet, this respect and this love for the reality of things does not suffice alone to explain or to characterize the profound,

complex, and quite distinctive art of Vincent van Gogh. No doubt, like all the painters of his race, he is very conscious of material reality, of its importance and its beauty, but even more often, he considers this enchantress only as a sort of marvelous language destined to translate the Idea. He is, almost always, a Symbolist…who feels the continual need to clothe his ideas in precise, ponderable, tangible forms, in intensely sensual and material exteriors. In almost all his canvases, beneath this morphic exterior, beneath this flesh that is very much flesh, beneath this matter that is very much matter, there lies, for the spirit that knows how to find it, a thought, an Idea, and this Idea, the essential substratum of the work, is, at the same time, its efficient and final cause. As for

the brilliant and radiant symphonies of color and line, whatever may be their importance for the painter, in his work they are simply expressive *means,* simply *methods* of symbolization. Indeed, if we refuse to acknowledge the existence of these idealistic tendencies beneath this naturalist art, a large part of the body of work that we are studying would remain utterly incomprehensible. How would one explain, for example, *The Sower,* that august and disturbing sower, that rustic with his brutally brilliant forehead (bearing at times a distant resemblance to the artist himself), whose silhouette, gesture, and labor have always obsessed Vincent van Gogh, and whom he painted and repainted so often, sometimes beneath skies rubescent at sunset, sometimes amid the golden dust of blazing noons—how could we explain *The Sower* without considering that *idée fixe* that haunts his brain about the necessary advent of a man, a messiah, sower of truth, who would regenerate the decrepitude of our art and perhaps of our imbecile and industrialist society? And how could we explain that obsessive passion for the solar disk that he loves to make shine forth from his emblazoned skies, and, at the same time, for that other sun, that vegetable-star, the sumptuous sunflower, which he repeats, tirelessly, monomaniacally, if we refuse to accept his persistent preoccupation with some vague and glorious heliomythic allegory?

G.-Albert Aurier
"The Isolated Ones: Vincent van Gogh"
Mercure de France, January 1890

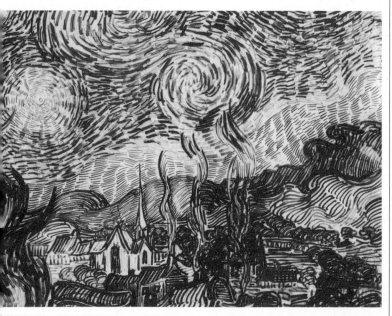

Vincent's Glory

Ever since the sale of van Gogh's Sunflowers *at Christie's in 1987, his name has been synonymous with prices in the millions of dollars. This is an awful misunderstanding, not because Vincent was fasting when he painted this picture, as he was still waiting for the 50 francs Theo had promised him, but because he thought only about painting. To look at* Sunflowers *is not simply to look at an investment.*

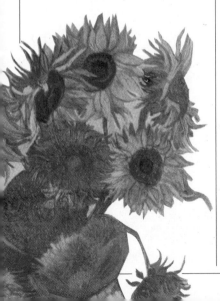

With the price of $36,292,500 paid for van Gogh's *Sunflowers*, the art market has crossed the most important barrier in its postwar history. This took place in London, at Christie's, on 30 March 1987, at 7:30 P.M.

At a stroke, several things became absolutely clear. The first was the evolution in the art market itself, which has been transformed, in the space of twenty-five years, from the club it used to be into an international arena. It used to be the domain of an elite belonging to the European aristocracy and upper middle class and their American counterparts, based in the Northeast of the United States. Lower down on the financial ladder but not on the aesthetic ladder, there were also a large number of enthusiastic collectors who had trained themselves "on the job," a Balzacian world of characters like Cousin Pons, which was familiar to those who frequented the Drouot auction rooms in Paris in the 1950s.

Such characters have disappeared, the old-style middle classes are in decline. Their place is being taken by an undifferentiated class, often representing new money, who buy according to new criteria. They are looking for something that is absolutely certain. They need a form of art that displays its aesthetic characteristics and its monetary value at the first glance. This kind of art is reassuring because it minimizes the risk of errors that could be made, bearing in mind their limited and newly acquired artistic knowledge, and because it serves as an external sign of Culture. For these collectors, the art of the great Impressionist and modern masters is the ideal.

What is also clear now is the triumph of the auction as a major event in the

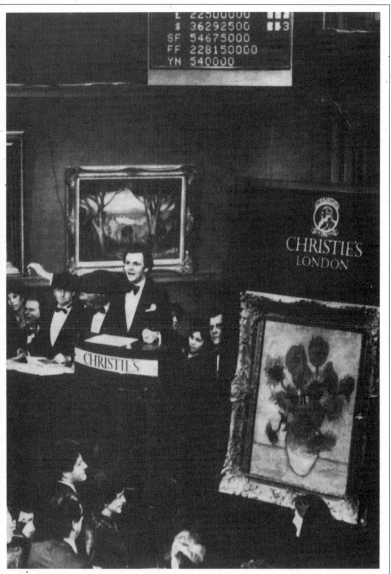

The sale of *Sunflowers,* Christie's London, 30 March 1987.

artistic world. Auctions now command as much attention as the things that once nourished them, exhibitions and museums. On the day of the sale, all the main television companies were there.

The third conclusion one can draw is that we are living through the end of a period in which the masterpieces of the great painters of the end of the nineteenth and of the twentieth centuries were still available. There are no more great Renoirs or Monets on the market. It would almost be true to say that only secondary works by those artists ever go on sale today. Attention has now turned to what comes after Impressionism: van Gogh, Toulouse-Lautrec, the Gauguin of the Tahiti years, the Fauves, Cubism from 1911 to 1914. In the case of van Gogh, major works from the last years of his life (Arles, Saint-Rémy, Auvers) can no longer be found. The *Sunflowers* sold at Christie's, painted in January 1889, are ranked just below those works. But it is the last of the five large canvases that he painted on that subject in the yellow house in Arles. It is the most important and doubtless the finest of them.

Christie's launched a masterful publicity campaign, sending the painting to the United States and to Japan. They publicized the event so well that a week before the sale, it was featured on the cover of the international edition of *Newsweek*.

The painting was given number 43, last in a catalogue in which there were enough interesting paintings to arouse excitement in the room. A fine Fauve painting by André Derain went for $3.3 million; a Modigliani for $3.7 million; a Mondrian for $200,000. None of this was enough to satisfy the audience's enthusiasm.

When the time came for the van Gogh, all the people in the room held their breath. The density of millionaires per square meter was the highest ever observed. After sixty seconds, the bidding broke through a historic barrier, the first one since the Jakob Goldschmidt sale of 1957 at which seven Impressionist paintings had been sold by Peter Wilson for nearly $1.5 million dollars, a sale that marked the beginning of the irrepressible rise of Sotheby's. Thirty years later, Christie's had its revenge.

J. Roy
"The Millions of van Gogh"
L'Express, 10 April 1987

August 1888—March 1987. When he painted the Sunflowers*, Vincent did not have enough money to pay for the paints that, a hundred years later, would make his painting the object of one of the largest transactions ever to take place in the art world.*

My dear Theo,

Would you like to ask Tasset's opinion on the following question? To me it seems as though the more finely a color is brayed, the more it becomes saturated with oil. Now needless to say, we don't care overmuch for oil.

If we painted like Monsieur Gérôme and the other trompe l'oeil photographers, we should doubtless ask for very finely brayed colors. But we on the contrary do not object to the canvas having a rough look. If then, instead of braying the color on the stone for God knows how many hours, it was brayed just long enough to make it manageable, without worrying too much about the fineness of the powder, you would get fresher colors that would

perhaps darken less. If he wants to make a trial of it with the three chromes, the malachite, the vermillion, the orange lead, the cobalt, and the ultramarine, I am almost certain that at much less cost I should get colors that would be both fresher and more lasting. Then what would the price be? I'm sure this could be done. Probably also with the reds and the emerald, which are transparent.

I enclose an order, which is urgent.

I am now on the fourth picture of sunflowers. This fourth one is a bunch of fourteen flowers, against a yellow background, like a still life of quinces and lemons that I did some time ago.

Only as it is much bigger, it gives a rather singular effect, and I think that this one is painted with more simplicity than the quinces and lemons.

Do you remember that one day we saw a very extraordinary Manet at the Hotel Drouot, some huge pink peonies with their green leaves against a light background? As free in the open air and as much a flower as anything could be, and yet painted in a perfectly solid impasto, and not the way Jeannin does it.

That's what I'd call simplicity of technique. And I must tell you that nowadays I am trying to find a special brushwork without stippling or anything else, nothing but the varied stroke. But someday you'll see.

What a pity painting costs so much! This week I had fewer worries than other weeks, so I let myself go. I shall have spent the 100-franc note in a single week, but at the end of this week I'll have my four pictures, and even if I add the cost of all the paint I have used, the week will not have been sheer waste.

I have got up very early every day, I have had a good dinner and supper, and so I have been able to work hard and long without feeling myself weaken. But there, we live in days when there is no demand for what we are making; not only does it not sell, but as you see in Gauguin's case, when you want to borrow on the pictures, you can't get anything, even if it is a trifling sum and the work, important. And that is why we are the prey of every happening. And I am afraid that it will hardly change in our lifetime. But if we are preparing richer lives for the painters who will follow in our footsteps, it will be something.

But life is short, and shorter still is the number of years you feel bold enough to face everything.

And in the end it is to be feared that as soon as the new painting is appreciated, the painters will go soft.

But anyway, this much is positive, it is not we of the present time who are decadent. Gauguin and Bernard talk now of "painting like children"—I would rather have that than "painting like decadents." How is it that people see something decadent in Impressionism? It is very much the reverse.

I enclose a line for Tasset. The difference in price ought to be considerable, and needless to say, I hope to make less and less use of finely brayed colors. With a handshake.

One of the decorations of sunflowers on royal blue ground has "a halo," that is to say each object is surrounded by a glow of the complementary color of the background against which it stands out. Good-bye for now.

Ever yours, Vincent
Arles, August 1888

The Miners of the Borinage

In the Borinage, a mining region in Belgium near the French border, Vincent shared the life of the poorest of the poor in the name of the Gospel. It was these miners of the Borinage who were called upon to work in the mine during the strike described in Emile Zola's Germinal. *The poverty of these Belgian strikebreakers was the same as that of the French miners Zola visited in 1884. This was the poverty Vincent himself experienced six years earlier.*

Zola's Research Notebooks *are the work of an ethnographer as much as of a novelist. When preparing each of the Rougon-Macquart novels, Zola took notes in the field, going from the banks of the Seine and the fields of the Beauce to the station in Le Havre, from the department stores of Paris to the terrible life to be observed in the miners' homes, which he describes here.*

The Coal Miner's Day

The men in the miners' houses get up at 3 A.M. Their wife or grown-up daughter gets up with them to make the coffee. They shake the grill on the stove and the fire which has smouldered all night long reappears. The coffee is drunk, the lamp is checked and carried off; the miners like to go to the shed a little early to warm their backs for a quarter of an hour or twenty minutes. This allows those who have arrived first to go down the shaft. They await their turn to go down by the fire. Down below, at the seam and everywhere else they generally only speak about their work, about the difficulties they have encountered, or their hopes of completing a task…. Besides, they are not talkative, they take turns to speak and speak slowly (note the huge difference from the workers of Paris). From the mine some go straight home, others go and drink a pint of beer at the café before going home. They don't buy each other drinks but have their drinks by themselves, in silence, sitting down at one of the tables against the wall; they empty their glasses in two or three gulps. Only a few words are exchanged with those who enter. Eventually the miner goes home and eats his soup (with or without fat) before washing. It is 3 or 4 P.M. The soup is usually herb

Plan of Etten and of its surroundings, drawn by Vincent in July 1878.

soup or, two or three times a week, soup containing bacon or fat. He then eats some stew, if there is any, or a piece of bread and butter, or else nothing. Finally, he has a wash or gets his wife to wash him. Then he strolls around, going to the café if he has any money, has a game of skittles or cards, has two or three pints, and waits until 7 P.M. for the family dinner. The whole family is there; they have supper or a piece of bread and butter and coffee with milk or a salad, which he adores. They don't eat much for supper. Finally, he goes to bed at 8 P.M. By 9 all the lights are out in the miners' houses From 8 P.M. to 3 A.M. he sleeps. It takes him about an hour to get up, go to the mine shaft, and go down.

On Sunday he doesn't work. Those who like to sleep do not get up until 9 A.M., and those who can't sleep get up at 6. The miner gets up, sits around in the morning, works in his garden, tidies the shed where there is a wheelbarrow, rabbits, etc. In the morning after getting up, he eats a piece of bread and butter. At noon the family has dinner, soup and beef, fattened rabbit. Rabbit is the miners' great delicacy; when one • miner wants to insult another he says to him, "You gave the foreman a rabbit," meaning, "You bribed him." In the afternoon the men start going around to the cafés and bars, where they can get drunk. Five percent of married men and twenty percent of young men are drunkards. They drink, they play, they go from one bar to another, knowing where their friends go and looking for them. When the miner gets home, at 9 or 10 P.M., he has very little supper, eating what is left over from the midday meal. Sometimes, in the well-run households, his wife and children go

and find him in the bar, especially in one of those where there is a dance on. Sometimes they agree on this beforehand; at other times, the family goes looking for the father, knowing his habits and where he goes. The daughters dance. They all go home at 11 P.M. Everything is closed by then.

On holidays, such as the Feast of St. Barbara, they celebrate. They do not work the day before or the day after, or the day after that. They get much more drunk. There has to be rabbit.

<div style="text-align: right">

Emile Zola
Research Notebooks

</div>

Obsessed by the conviction that by living with simple people, such as the miners of the Borinage, he could fight against the selfishness of man, Vincent set off in the summer of 1878 for that terrible region of Wallonia, where the black pyramids that symbolize the life of the coal miner stand out against a sky saturated with carboniferous gas.

LETTER TO THEO

When I was in England, I applied for a position as evangelist among the coal miners, but they put me off, saying I had to be at least twenty-five years old. You know how one of the roots or foundations, not only of the Gospel, but of the whole Bible, is "Light that rises in the darkness." From darkness to light. Well, who needs this most, who will be receptive to it? Experience has shown that the people who walk in the darkness, in the center of the earth, like the miners in the black coal mines, for instance, are very much impressed by the words of the Gospel and believe them, too. Now in the south of Belgium, in Hainaut, near Mons, up to the French frontier—yes, even far across

it—there is a district called the Borinage, which has a unique population of laborers who work in the numerous coal mines. I found the following about them in a little geography:

The Borins (inhabitants of the Borinage, situated west of Mons) find their employment exclusively in the coal mines. These open mines are an imposing sight, 300 meters underground; groups of working men, worthy of our respect and sympathy, daily descend into them. The miner is a type peculiar to the Borinage; for him daylight does not exist and he sees the sunshine only on Sunday. He works laboriously by the pale, dim light of a lamp, in a narrow tunnel, his body bent double, and sometimes he is obliged to crawl. He works to extract from the bowels of the earth that mineral substance of which we know the great utility; he works in the midst of thousands of ever-recurring dangers; but the Belgian miner has a happy disposition, he is used to the life, and when he goes down into the shaft, wearing on his hat a little lamp to guide him in the darkness, he entrusts himself to God, Who sees his labor and protects him, his wife, and his children....

I should very much like to go there as an evangelist. The three months' probation demanded of me by the Reverend Mr. de Jong and the Reverend Mr. Pietersen have almost passed.... If I could work quietly in such a district for about three years, always learning and observing, then I should not come back without having something to say that was really worth hearing. I say this in all humility and yet with confidence. If God wills, and if He spares my life, I would be ready by about my thirtieth year—beginning with my own unique training and experience, mastering my work better and being riper for it than now....

There are many little Protestant communities in the Borinage already,

The Decrucq house in Cuesmes.

The Denis house.

Entrance to the L'Agrappe house.

and certainly schools also. I wish I could get a position there as an evangelist in the way we talked about, preaching the Gospel to the poor—those who need it most and for whom it is so well suited—and then devoting myself to teaching during the week.

You have certainly been to St. Gilles? I also made a trip that way, in the direction of the Ancienne barrière. Where the road to Mont St. Jean begins there is another hill, the Alsemberg. To the right is the cemetery of St. Gilles, full of cedars and ivy, from which one can see the whole city. Proceeding farther, one arrives at Forest. That

region is very picturesque; on the slopes of the hills are old houses like those huts in the dunes that Bosboom sometimes painted. One sees all kinds of labor performed in the fields: sowing corn, digging potatoes, washing turnips; everything is picturesque, even gathering wood, and it looks much like Montmartre. There are old houses covered with ivy or vines, and pretty little inns; among the houses I noticed was that of a mustard manufacturer, a certain Verkisten; his place was just like a picture by Thijs Maris, for instance. Here and there are places where stone is found, so there are small quarries through which pass sunken

Mine-shaft number 7 at the Marcasse mine.

Shaft number 10 at the Grisœil mine.

Shaft number 1 at the Sac mine.

roads with deep wagon ruts; along them one can see little white horses decorated with red tassels and the drivers wearing blue blouses, an occasional shepherd, too, and women in black dresses and white caps who remind one of those by de Groux.

There are some places here—thank God one finds them everywhere—where one feels more at home than anywhere else, where one gets a strangely old feeling tinged with bitter melancholy almost like homesickness; yet it stimulates us, encourages and cheers the spirit, and gives us—we do not know how or why—new strength and ardor for our work. That day I walked on past Forest and took a side path leading to a little old ivy-colored church. I saw many linden trees there, even more interwoven and more Gothic, so to speak, than those we saw in the park; and at the side of the sunken road leading to the church-yard were twisted and gnarled stumps and tree roots, fantastic, like those Albrecht Dürer etched in *Ritter, Tod und Teufel.*

Have you ever seen a picture, or rather a photograph, of Carlo Dolci's *The Garden of Olives?* There is something Rembrandtesque about it; I saw it the other day. I suppose you know that large rough etching of the same subject after Rembrandt; it is the pendant of that other, *The Bible Reading,* with those two women and a cradle. Since you told me that you had seen the picture by Father Corot on the same subject, I remembered it again; I saw it at the exhibition of his works shortly after his death, and it affected me deeply.

How rich art is; if one can only remember what one has seen, one is never without food for thought or truly lonely, never alone.

Lacken, 15 November 1878

The Denis house.

Places in His Life
Places He Saw

"Violet town, yellow star, blue-green sky. The wheatfields are all the color of old gold, copper, or green, or red, or yellow...." Vincent's words reveal his preoccupation: Landscapes, houses, bridges, skies, everything is food for his eyes. The many places through which he passed were material for his creative power.

The presbytery at Nuenen with Vincent's studio at right.

The painter's apartment and studio, Rue Lepic, Paris.

The house in Arles in which van Gogh lived from 1887 to 1888.

The Langlois bridge in Arles, destroyed during World War II.

The asylum Saint-Paul-de-Mausole, in Saint-Rémy-de-Provence, and the garden.

The garden of the asylum as drawn by Vincent.

The garden of the asylum, Saint-Rémy-de-Provence.

The café in which van Gogh died, Auvers-sur-Oise.

Further Reading

Artaud, Antonin. *Van Gogh le suicidé de la société*. Paris, 1947

Bonafoux, Pascal. *Van Gogh par Vincent*. Paris, 1986

Cabanne, Pierre. *Van Gogh*. Trans. M. Martin. Englewood Cliffs, N.J.: Prentice-Hall, 1963

Cogniat, Raymond. *Van Gogh*. Trans. J. Cleugh. New York: Harry N. Abrams, 1959

The Complete Letters of Vincent van Gogh. Introduction by V. W. van Gogh. Preface and memoir by J. van Gogh-Bonger. 3 vols. London: Thames & Hudson; Greenwich, Conn.: New York Graphic Society, 1958

Courthion, Pierre. *Van Gogh raconté par lui-même, ses amis, ses contemporains, sa postérité*. Paris, 1947

Doiteau, Victor, and Edgar Leroy. *La Folie de Vincent van Gogh*. Paris: Aesculape, 1928

Duthuit, Georges. *Van Gogh*. Lausanne, 1948

Faille, de la, J.-B. *The Works of Vincent van Gogh*. Amsterdam: Meulenhoff International; New York: Reynal, 1970

Fels, Florent. *Van Gogh*. Paris: H. Fleury, 1928

Florisoone, Michel. *Van Gogh*. Paris: Plon, 1937

Forrester, V. *Van Gogh ou l'enterrement dans les blés*. Paris, 1983

Hammacher, A. M., and R. Hammacher. *Van Gogh*. London: Thames & Hudson, 1982

Hautecoeur, L. *Van Gogh*. Munich/Paris, 1946

Hulsker, Jan. *The Complete Van Gogh: Paintings, Drawings, Sketches*. New York: Harry N. Abrams, 1980

Huyghue, René. *Vincent van Gogh*. Trans.

Helen Slonim. New York: Crown, 1958

Jewell, E. A. *Vincent van Gogh*. New York, 1946

Leymarie, Jean. *Van Gogh*. Paris: P. Tisné, 1951

———. *Who Was Van Gogh?* Geneva: Skira, 1968

Marois, Pierre. *Le Secret de Van Gogh*. Paris: Stock, 1953

Mauron, Charles. *Notes sur la structure de l'inconscient chez Van Gogh*. Paris, 1953

McQuillan, Melissa. *Van Gogh*. London: Thames & Hudson, 1989

Meier-Graefe, Julius. *Vincent van Gogh, a Biographical Study*. Trans. John H. Reese. 2 vols. London: Medici Society, 1922

Parronchi, Alessandro. *Van Gogh*. Florence: Arnaud, 1949

Perruchot, Henri. *La Vie de Vincent van Gogh*. Paris: Hachette, 1955

Pickvance, Ronald. *Van Gogh en Arles*. Geneva: Skira, 1985

Pierard, Louis. *The Tragic Life of Vincent van Gogh*. Trans. Herbert Garland. London: John Castle, 1925

Rewald, John. *Post-Impressionism: From Van Gogh to Gauguin*. 3rd ed. New York: The Museum of Modern Art, 1978

Stein, Susan Alyson, ed. *Van Gogh, A Retrospective*. New York: Crown, 1986

Terrasse, C. *Van Gogh*. Paris, 1935

Tralbaut, Marc Edo. *Vincent van Gogh*. Trans. Margaret Shenfield. New York: Viking Press, Studio Books, 1969

Wallace, Robert. *The World of Van Gogh*. New York: Time-Life Books, 1969

List of Illustrations

Index

Photograph Credits

The publishers wish to thank the museums and private collectors named in the illustration captions for graciously giving permission to reproduce certain works of art and for supplying necessary photographs. Additional photograph credits are listed below.

Archives Gallimard, Paris 15, 17, 22, 24, 25, 26–27b, 33, 37, 43, 44, 47, 51, 52b, 58, 61, 70, 73, 90a, 91a, 99, 104, 114, 115l, 116b, 116–17a, 127, 131, 133, 134, 136, 139. Artephot/ Agraci, Paris 20–21. Artephot/Faillet, Paris 18a. Artephot/Held, Paris 76a, 98, 102. Artephot/Lavaud, Paris 124–25. Artephot/Nimatallah, Paris 118–19. Artephot/ Takase, Paris 34–35, 83. Ashmolean Museum, Oxford, England 78b. Collection Sirot-Angel, Paris 28. Edimédia, Paris 50b, 82b, 84, 88, 90b, 91b, 92, 129. Giraudon, Paris 29, 54–55, 70r, 93, 115r. Giraudon/Bridgeman, Paris 18–19. Kröller-Müller Museum, Otterlo 36, 39, 45, 60, 62, 63, 71, 105. Kunsthalle, Bremen 154–55. The Metropolitan Museum of Art, New York 107. Neue Pinakothek, Munich 156. Private Collection 108–9, 140–41, 147. Réunion des Musées Nationaux, Paris 27a, 42–43, 64, 100, 110–11, 112–13, 117b. Rights Reserved 130, 150, 152, 157. Rijksmuseum Vincent van Gogh, Amsterdam *front cover,* 11–16, 23, 30–32, 40–46, 48, 49, 50a, 53, 54a, 56, 57, 62–63, 65, 68–69, 72, 73, 74, 76b, 77, 78a, 79, 80, 81, 82a, 85, 86–87, 89, 94, 96, 97, 101, 103l, 106, 120–21, 122–23, 126–27, 140, 142, 148, 160, 161, 163, 164–66. Roger-Viollet, Paris 144, 168, 169.

Text Credits

Grateful acknowledgment is made for use of material from the following works:

Artaud, Antonin, *Selected Writings,* from *Oeuvres complètes,* © Gallimard; English-language translation by Helen Weaver, copyright © 1976 Farrar, Straus and Giroux, Inc. *The Complete Letters of Vincent van Gogh,* English-language translation copyright © 1959; reprinted by permission of Little Brown, Inc., in conjunction with the New York Graphic Society, All Rights Reserved. Gauguin, Paul, *The Writings of a Savage,* © Gallimard 1974; English-language translation © 1978 by Penguin, reprinted by Viking Penguin, Inc., a division of Penguin Books U.S.A. Mirbeau, Octave, "Vincent van Gogh," in *Journal,* 17 March 1901. Roy, J., "Les Milliards de Van Gogh," in *L'Express,* 10 April 1987. *Van Gogh, A Retrospective,* edited by Susan Alyson Stein, © 1986, Hugh Lauter Levin Associates, Inc. (Aurier, G.-Albert, "The Isolated Ones: Vincent van Gogh"; Mirbeau, Octave, "Le Père Tanguy")

Pascal Bonafoux is an art historian and author whose works include *Rembrandt, autoportrait*, winner in 1985 of the Académie Française's Prix Charles-Blanc and the Prix Elie Faure et Gutenberg; *Van Gogh par Vincent*, 1986; and the novels *Annonce classé*, 1985, and *Blessé grave*, 1987.

Translated from the French by Anthony Zielonka

Project Manager: Sharon AvRutick
Editor: Harriet Whelchel
Typographic Designer: Elissa Ichiyasu
Design Assistant: Catherine Sandler
Text Permissions: Catherine Ruello
Editorial Interns: Glenna Berman, Caroline Jones

Library of Congress Catalog Card Number: 91–75512

ISBN 0–8109–2828–0

Copyright © Gallimard 1987

English translation copyright © 1992 Harry N. Abrams, Inc., New York, and Thames and Hudson Ltd., London

Published in 1992 by Harry N. Abrams, Incorporated, New York
A Times Mirror Company

Printed and bound in Italy by Editoriale Libraria, Trieste